I just bought a Digital Camera, Now What?!™

by Dave Johnson

SILVER LINING BOOKS

NEW YORK

For information contact:
Silver Lining Books
122 Fifth Avenue
New York, NY 10011

First Edition
This edition was published by Silver Lining Books.

Printed and Bound in the United States of America

Other titles in the Now What?!™ series:

I'm turning on my PC, Now What?!
I'm turning on my iMac, Now What?!
I'm in the Wine Store, Now What?!
I'm in the Kitchen, Now What?!
I need to get in Shape, Now What?!
I need a Job, Now What?!
I haven't saved a Dime, Now What?!
I'm on the Internet, Now What?!
I'm Retiring, Now What?!
I'm getting Married, Now What?!

introduction

"Okay, I admit it. My digital camera is still in the box. There's the little instruction book in there, too," confided my very smart, but very technophobic friend. "I took it out once, but all the weird words threw me. What's an LCD anyway?"

Ah, the challenge of learning new things. The problem starts with all the strange words, such as memory card, LCD, and .tif files, to name a few. And then comes the high-wire act of actually using these high-tech thingy-whatchies and before you know it, your digital camera is back in its box. When it comes to new technological marvels, we know just how scary they can be.

That's why we created **I just bought a Digital Camera, Now What?!** It's designed to walk you through the puzzling, anxiety-producing world of digital photography. We've eliminated the jargon and defined the high-tech words in plain English to prove to you that learning how to use a digital camera can be easy, even... fun! The author, Dave Johnson, is the main man when it comes to digital know-how, so you are in safe hands. It's time now to take your camera out of the box and get snapping.

Barb Chintz
Editorial Director, the *Now What?!*™ series

table of contents

CHAPTER 1

The digital camera

the digital camera versus 35 mm

Congratulations for being a true pioneer! Sure, lots and lots of people have bought digital cameras, but they're still a tiny minority compared to all the folks with good old film cameras. You may not feel like the leader of a revolution, but in a sense you are because digital cameras totally change the way that you interact with your camera and your pictures.

For starters, there's no film in your camera—just a digital **memory card** (a device that stores your pictures). There's nothing to replace every time you want to take more pictures, so you save money on film and developing costs. Just like a regular camera, a digital camera lets you see what you are shooting. But what's neat is that you can see what you just shot in the **LCD** (liquid crystal display)—a mini TV screen on the back of the camera. There's no waiting to get film developed. And best of all, you don't have to process and print every single picture on the roll. Instead, you can discard the pictures you don't like and just print the ones you do.

35-mm camera

Despite the differences, digital cameras are still just cameras. If you know how to use a regular 35-mm SLR (**single lens reflex**) or point-and-shoot camera, you shouldn't be too perplexed by these modern digital marvels. But if you feel a headache coming on at the sound of words like USB, SmartMedia, and CCD, don't worry—this book is here to help.

INSIDE THE CAMERA

Instead of film, a digital camera uses light-sensitive computer chips called **CCD** (which stands for Charge Coupled Device). There are several chips inside. When you press the shutter release, the CCDs are briefly exposed to light. The CCDs react to light and generate electrical signals, which "photographs" the scene. Those signals are then stored on a memory card. You can display, print, delete, or download the images and then use the memory card all over again.

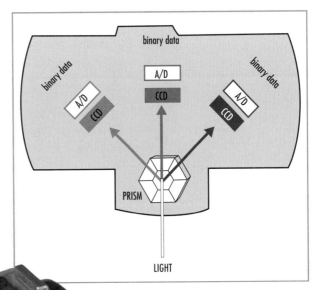

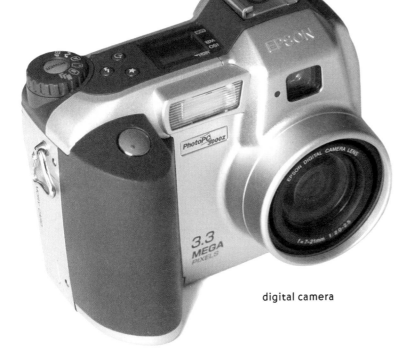

digital camera

choosing a camera

What to know if
you're still shopping

Digital cameras, like cars, bread machines, and home stereos, come in all shapes, sizes, and price ranges. Choosing the right one can sometimes seem as confusing as trying to order a simple cup of coffee from one of those high-end java shops.

Really, though, you can divide digital cameras into three main categories: budget cameras, performance cameras, and professional models.

Budget Budget cameras are generally **low-resolution** starter models, called **one-megapixel cameras** because they can capture a million **pixels** (the dots that make up a picture) in each image. As you may have guessed, resolution refers to the number of pixels that make up a picture. One million might sound like a lot of pixels, but a resolution of 1280 x 960 pixels (that's a million) shouldn't be printed any bigger than 4 x 6 inches. These starter models are inexpensive—typically under $300.

Performance These days, performance cameras are **two- and three-megapixel** models that are priced between $400 and $1000. Their higher resolution lets you print images as large as 8 x 10 inches. They also come packed with lots of advanced features like zoom lenses, super-accurate exposure metering, and the ability to capture short movies in addition to still images.

Professional Starting at $2000, these cameras are overkill for most folks. But they tend to offer higher resolution, interchangeable lenses, and huge image-storage capacities.

SK THE EXPERTS

What features are most important in a digital camera?

Your camera should have enough **resolution** (the number of pixels in a picture) to print pictures as large as you need. If you want to make your own 8 x 10s, for instance, buy a three-megapixel camera. Aside from that, a long optical zoom is handy, as well as a choice of exposure modes—the same sort of stuff you'd look for in a 35-mm camera.

Is it safe to buy a digital camera online?

Absolutely. You can find some excellent deals on the Internet, but be sure to buy smart. Only enter your credit card information in secure Web sites—you should see a padlock or key icon in your Web browser's status bar at the bottom of the purchase page before you enter your credit card number.

Can I use a digital camera without a computer?

Yes, you can. Without a computer, you can connect most cameras to your television to see images as a video slide show. With the right camera and printer, you can also print images without using the computer. And there are photo shops that accept memory cards and print your images for you. But with a computer, you can also edit pictures exactly to your liking, print them, and post them to Web sites.

all about features

What's in your digital camera

So, you have used a 35-mm camera and you think you're all set to start snapping digital pictures. Great! Just know that there are a few new things to master with a digital camera. You certainly don't have to learn how to use all the extra features—especially right away—but if you tackle a few new features each week, in a month or two you'll know all the ins and outs of your camera.

A Mode controls

B Built-in flash

C Optical viewfinder (front)

D Hot shoe for external flash

E Optical viewfinder (back)

F LCD display

G Zoom feature

H Settings dial

I Shutter release

SPECIAL FEATURES

Playback The back of your digital camera has a playback mode that lets you see all of the images you've already taken, on the **LCD display**—the little window that lets you preview your image (see page 20). Not only can you see each image, but in some digital cameras you can also zoom in and pan around the image to see how well the entire picture came out.

Panorama mode Your camera might have "guides" that let you easily take a series of pictures and stitch them together on the computer into a large panoramic photo. In order for a panorama to work, the images need to overlap so the computer software can stitch them together seamlessly.

Movie mode If you want to capture a 30-second clip of the puppies jumping all over your grandson, then your camera's movie mode is just the thing. Many cameras can capture short video sequences that can be played back on the computer or displayed on a Web page.

False color mode To satisfy your creative streak, many cameras include photo modes that capture your images in sepia, black-and-white, negative, and other color modes. Sure, you can process photos on the computer to achieve the same effect, but it's mighty convenient to capture a family shot at the Old West town in sepia mode right in the camera, no extra work required.

resolution

How detailed are your pictures?

In photography, resolution is the word used to describe a picture's clarity. In digital photography, clarity is based on the number of pixels (or color dots) in the image. With regular cameras, there are no dots—just a continuous blend of colors that can look good even when you enlarge them as big as 16 x 20 inches. It's really hard for digicam (tech speak for digital camera) manufacturers to pack that many pixels onto a CCD chip (a light-sensitive computer chip that forms the image at the moment of exposure). So the more afford- able cameras compromise and offer a lower maximum resolution than 35-mm cameras. With most digicams, you have to settle for printing 5 x 7s and 8 x 10s. Any bigger than that and you lose your resolution. But that's probably okay—how often do you really need to make poster-size prints?

The image at right was shot at a resolution of 640 x 480. The image at far right was shot at a resolution of two megapixels.

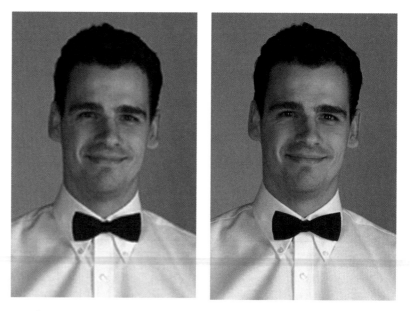

Resolution is important, but it isn't everything. After all, if you're planning to e-mail pictures to a friend or post some images to a Web page, too much resolution is a bad thing, since smaller files travel across the Internet faster. And big, three-megapixel images fill up your memory card quickly. Smaller files let you take a lot more pictures without putting in a new memory card. (More about this on page 18.)

WHAT IF

You want to take pictures for the Web with a high-resolution camera?

A three-megapixel image is way too big for the Internet, but fortunately, digital cameras let you choose the resolution you shoot with. You can just dial in the size of your picture before you take it.

Use this chart to decide what resolution to use when shooting pictures with your digital camera.

RESOLUTION	ADVANTAGES	DISADVANTAGES	IDEAL FOR
640 x 480	You can fit a lot of pictures on a memory card or in your computer	Too small to print and display	Posting to Web pages or sending in e-mail
One megapixel (one million pixels)	The file size is still pretty small, great for packing images onto memory cards	Too big for the Web, too small for most print jobs	4 x 6-inch prints. You can also use the extra size to crop snapshots to make better pictures for the Web
Two or three megapixels (two or three million pixels)	You can crop these pictures a lot and the picture will still be big enough to print or e-mail	Memory cards fill up fast	Printing pictures at 5 x 7, 8 x 10, and sometimes larger

your lens

What you need to know about the lens

Without a lens, your camera is really just an expensive paperweight. Though some inexpensive cameras have a fixed lens that can't zoom in or out, most cameras include some sort of zoom lens for changing magnification. Zoom lenses are great because they let you move in and get a tighter shot of the action without walking forward—or zoom out and get a more expansive view without stepping backward.

There are two kinds of zoom features in most digital cameras.

Optical Zoom An optical zoom uses a system of lenses to magnify the image. Optical zooms give excellent results, but large zooms—more than 3x magnification, for instance—are expensive and hard to find in digital cameras.

Digital Zoom Digital zooms are popular because they're inexpensive and they have impressive-sounding magnification, like 4x or even 10x. But don't get carried away. You see, a digital zoom doesn't optically magnify the scene at all—it just grabs the pixels in the middle of the picture and enlarges them, giving you a blurry enlargement of part of the original image. Not great.

Most cameras include both optical and digital zooms. After you zoom optically, the digital zoom might take over and continue enlarging the image. You should avoid the digital zoom most of the time since you can do your own enlargements on the PC and probably get better results anyway.

HAT'S OUT THERE

Digital cameras come, as you've already seen, in all shapes and sizes. And they come with all sorts of lenses.

If you want to get into digital photography for a song—say for less than $200 or so—then look into a camera like the *Kodak DC210 Plus*. Equipped with a 48-mm lens, it has a simple digital zoom for pulling in more distant scenes.

If your finger itches to zoom in on the action, though, you should consider a camera with an optical zoom. The *Epson PhotoPC 3000Z*, for instance, has a 3x optical zoom—and if you need more, you can switch on the digital zoom to go all the way to 6x.

At the expensive end of the camera spectrum, there are cameras like the *Nikon Cool Pix 990*, a full-feature 3.3 megapixel camera. Professionals use even more elaborate cameras like the *Nikon D1*. Since the D1 uses ordinary Nikon interchangeable lenses, you can attach any lens you like. This is especially handy if you already own a Nikon 35-mm camera and have your own collection of lenses.

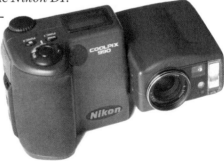

memory

Where your pictures
go after you press
the shutter release

Your camera's memory is often called digital film. Instead of loading roll after roll of $10 film into your camera, you load one memory card (approximately two inches square). Digital film is a completely reusable resource; when it is full of pictures, just download the images to your computer and erase the memory card, then start all over again.

Memory cards—or digital film—come in a few different styles, and your camera is probably designed to accept just one kind, such as Compact Flash or SmartMedia, which are different in size and shape.

However, don't feel limited by the one memory card that came with your camera. You can buy additional cards to use when you're away from home taking pictures. When your original card's storage capacity is full, just remove it, put in a blank one and keep shooting. And larger cards hold more pictures. Check out this chart to see how many of the highest resolution images you can store on various memory cards using a typical three-megapixel digital camera.

The amount of memory on the memory card	Maximum number of highest resolution images
8MB	6
16MB	12
32MB	24
64MB	48
128MB	96

1 Compact Flash
2 SD/MMC Card
3 Memory Stick
4 Floppy Disk
5 Smart Media

WHAT'S OUT THERE

There are four common varieties of memory cards on the market. They all look different, but they have one important thing in common: they store pictures in your camera.

Compact Flash — These cards are popular storage options because they come in a lot of memory sizes—everything from 8MB all the way up to a gigabyte! (A byte is a basic, tiny unit of storage on your computer. MB is a megabyte, meaning a million bytes; a gigabyte is a thousand megabytes.) That's a lot of room for digital pictures.

SmartMedia — Wafer thin, these memory cards top out around 64MB, but they have an ace up their sleeves—they are thin enough to slip into a special **memory-card reader**, which looks just like a floppy disk and fits in a computer's floppy disk drive. Insert the SmartMedia card reader into the floppy drive and you can transfer images as easily as copying files from a floppy disk.

Memory Stick — While Sony's exclusive Memory Stick isn't very popular, these cards (which look like a stick of gum) can plug into all sorts of devices. That means you can take your Memory Stick out of a camera and insert it into a number of products that can accommodate the Sony memory stick, such as a Sony laptop.

Floppy Disk — Some cameras (like the Sony Mavica line) still use floppy disks for storing images. It's handy, since you can just stick the floppy into your PC. Floppies can't hold a lot of data, though, and they're slow—so they're not a good choice for high-resolution cameras.

your viewfinder

There's more than one way to see your picture

You probably don't need a book to tell you that the viewfinder is your portal to what the camera sees. But most digital cameras have not one but two different viewfinders—each with its own purpose and unique quirks.

The **optical viewfinder** is a glass window to the other side of the camera. It's the same sort of finder you'll see in 35-mm point-and-shoot cameras. It's fine for most photography, but keep in mind that when you get really close to your subject, it won't show you exactly what the camera is about to photograph.

For serious close-ups, you'll need to use the **digital viewfinder** (also known as the LCD display), which is like a mini TV window of what you are photographing. Located on the back of the camera, it shows you exactly what the camera's lens sees. But since it's electronic, it gobbles up your camera's battery life like a hungry puppy in a Purina factory.

THE TWO VIEWFINDERS

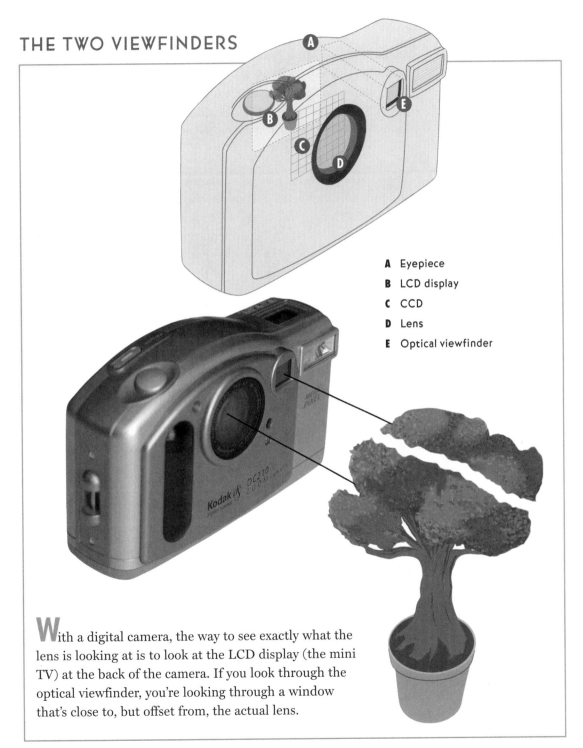

A Eyepiece
B LCD display
C CCD
D Lens
E Optical viewfinder

With a digital camera, the way to see exactly what the lens is looking at is to look at the LCD display (the mini TV) at the back of the camera. If you look through the optical viewfinder, you're looking through a window that's close to, but offset from, the actual lens.

the flash

Let there be light!

Almost every digital camera on the market includes a built-in electronic flash. Sure, there are a few really inexpensive cameras out there that have no flash at all, but getting a camera that can't illuminate a dark scene is sort of like buying a car that doesn't have headlights. You can drive it in the daytime, and just hope you don't have to go anywhere after dark.

The flash on your camera has a maximum range of about 20 feet—and probably a bit less. That means you shouldn't try to illuminate a school play from halfway back in the auditorium. If you want more power, though, some digital cameras include a socket (also called a hot shoe) for attaching an external flash unit. These beefier flashes can light up a scene up to 40 or 50 feet away.

FIRST PERSON DISASTER STORY

Flash Too Bright For Close-ups

My husband has an extensive collection of model trains, elaborate tracks, and all of the scenery and accessories you might ever want to see. I got a digital camera with the intention of taking pictures of all these miniature gadgets and publishing them on a Web site. I ran into a problem, though—I had to get so close to the models that the flash was overexposing the pictures. Until then, I didn't realize that a flash could have a minimum range in addition to a maximum one. I asked a bunch of people what do, and no one had any solutions. But then I came up with a surprisingly simple fix all on my own—tissue paper! I found that I could cover the flash with a thin layer of tissue to get just the right amount of light in the picture. It takes a little experimentation, but heck, with digital film you can try over and over again.

Katie L., Bayonne, New Jersey

INSIDE THE CAMERA

While most cameras mount the flash on the front of the camera, right above the lens, a few cameras hide the flash in a pop-up panel. If you have such a camera, you'll need to activate the flash manually by extending the flash head before the camera can take pictures in the dark.

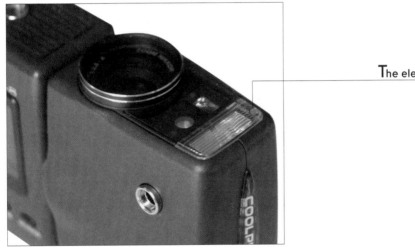

The electronic flash unit

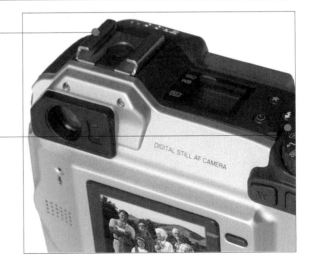

Hot shoe port—this is the place that you plug in external flash units if you need additional light.

Flash mode control—use this to turn your flash on, set the flash mode, and turn the flash completely off for situations when you don't want it to fire

menu options

Why your digital
camera is like a
computer

Buttons, buttons, and more buttons—some digital cameras are littered with controls all over the case. Other cameras have almost no buttons, dials, or controls at all. But if there aren't many buttons on your camera, how can you do things like select the picture resolution or focus mode? The answer lies inside with your camera's on-screen **menu**. Almost all digital cameras have a menu system that appears on the LCD display—the mini TV screen also known as the digital viewfinder—on the back of the camera.

You may not care about many of the options and settings in the camera's menu system. You may see controls for mysterious things like white balance, exposure bracketing, and ISO adjustment, for instance. But some genuinely useful features may be found in the menu as well—like resolution adjustment, flash settings, and the control to erase your memory card. It's not a bad idea to experiment with your menu and see what's in there, even if you don't need to muck around with many of the settings.

To turn on the menu, you need to find the button on your camera body that toggles the menu on and off. The button usually says MENU, though sometimes it'll be an icon that is supposed to look like a menu—such as several lines inside what looks like a TV screen. The same button should turn the menu on and off, and you can usually find a set of buttons near the LCD screen to navigate through the menus. Be sure to check your camera's users guide for details on how to use the menus.

INSIDE THE MENU

Here is a quick guide to many of the common controls in your camera's menu.

Resolution This setting lets you change the size of the pictures that your camera takes.

Quality Similar to resolution, image quality changes how much the images are compressed. High compression lowers visual quality but packs more pictures onto a memory card.

INSIDE THE CAMERA

Erase and format memory card These controls let you wipe a memory card clean to take more pictures. The erase tool lets you erase images one at a time (or the whole card at once) while the format option always wipes the whole card clean.

White Balance You probably don't need to mess with this control. White balance lets you tell the camera what is supposed to be white in a picture. If your images have an off-color cast, the white balance is out of adjustment for the light conditions you're shooting in.

Exposure bracketing This feature tells the camera to take three pictures at once—one properly exposed, plus one underexposed and one overexposed. If you're not sure that the exposure setting is right, this technique lets you get one picture exposed properly anyway.

Exposure and focus controls The menu system may also include "manual override" settings that allow you to take over the focus and exposure completely.

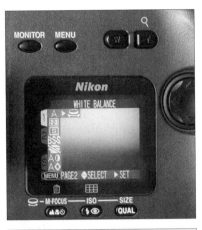

now what do I do?

Answers to common questions

Are there any places on the Internet I can go to find comparisons of various digital camera models?

There are a few Web sites that directly compare different cameras, and that's the best way to figure out how good a potential purchase is. Some of the best include **consumersearch.com** and **consumerreports.com**. Other sites, like **epinions.com** and **photo.cnet.com** include ratings and comments by visitors, not professional reviewers, but they're sometimes worth checking out as well.

I'm guessing that digital cameras are not waterproof.

Good guess. Digital cameras are highly sensitive to moisture. But if you want to use your digital camera for snorkeling or scuba diving, you'd probably like to know that several companies make special waterproof housings for a number of common digital camera models. Check out Sea & Sea (**www.seaandsea.com**) as well as Ikelite (**www.ikelite.com**).

Is it worth my while to buy rechargeable batteries for my digital camera?

Yes. Alkaline batteries simply don't last very long in digital cameras. They're not designed for the rigors and demands of digicams, and consequently you'll go through lots and lots of them. Instead, buy a set of NiMH rechargeable batteries and a charging station. You'll be able to take more pictures before you need to change or recharge them, and they'll pay for themselves in no time, sometimes in just a few weeks.

Where can I get rechargeable batteries and a charging station?

If you didn't get a complete rechargeable battery kit with your digital camera, you can pick one up at most electronics or photography stores. Be sure to look for NiMH rechargeable batteries—they should look like ordinary AA batteries.

What makes the price of digital cameras vary so dramatically?

There are really two things that affect the price of a camera: resolution (the picture's clarity) and lens quality. Extra features, like extra exposure modes, don't affect price nearly as much. Resolution is a biggie—three-megapixel (three million pixels, or color dots) cameras are priced at a premium because they let you print 8 x 10 inch enlargements, something you can't do with a one-megapixel (one million pixels) camera. Quality zoom lenses are also expensive, and a 4x optical zoom can add hundreds of dollars to the price of a camera.

Is it safe to put a digital camera in the X-ray machine at an airport?

Yes. Airports don't have particularly powerful X-ray machines. The bottom line is that airport metal detectors don't damage the data on digital cameras or their memory cards.

What on earth do all those terms and acronyms in camera advertisements mean?

CCD A Charge Coupled Device is the light-sensitive sensor that, when exposed to light, forms the image at the moment of exposure.

CMOS Complementary Metal Oxide Sensors are less-expensive alternatives to CCDs and are found in some cheaper cameras.

LCD The Liquid Crystal Display is the small digital viewfinder at the back of the camera that shows you exactly what you are photographing, allowing you to preview and review pictures on the camera itself.

Megapixel Refers to the maximum resolution (image clarity) of the camera: a one-megapixel model can take images with a million pixels (or color dots), such as 1280 x 960.

NOW WHERE DO I GO?!

CONTACTS

Canon	Minolta
www.usa.canon.com	**www.minolta.com**
Epson	Nikon
www.epson.com	**www.nikonusa.com**
Kodak	Olympus
www.kodak.com	**www.olympusamerica.com**

CHAPTER 2

Using your camera

using digital film

It's film you can use over and over again

Think of the **memory card** in your camera as the digital equivalent of film. Your images remain safely on the card for hours, days, or even years. But when you are ready to erase your pictures, the memory card is reusable. Wiped clean in seconds, your digital film can be used over and over again, an unlimited number of times.

Most users find that owning at least two memory cards is convenient, especially when traveling. If your main memory card fills up with pictures, it only takes a few seconds to remove it and insert a fresh card so you can keep on shooting. At your convenience, you can transfer the pictures from the first card to your computer and erase the card, so it's ready to be used all over again.

Erasing a memory card is easy—your camera has a menu option (see page 25) to erase all the images in its memory, usually somewhere in the setup or options menu. Check your camera's users guide to see where this feature is. Or, if you're in a hurry, you can probably just ask a teenager. You can also free up memory by deleting specific pictures that you no longer need, such as a picture you accidentally took of your thumb. Usually, in the camera's playback mode, you can eliminate individual images by selecting a button or icon shaped like a trash can.

SK THE EXPERTS

I do a lot of traveling. There are a few pictures of my family that I'd like to keep on my memory card all the time. Is there a way to protect them from being erased?

Sure there is. Most cameras let you protect specific images. Once protected, these images won't be removed even if you erase all the images using the camera's menu system. But watch out—if you select **format** in the menu option (see page 25) it will probably erase all the images, even protected ones. Be careful which menu option you choose.

Is there a way to delete a bad picture right away, as soon as I've taken it?

On most cameras, yes. Check the **LCD display** (the mini TV screen at the back of your camera) after you take a picture. It will appear for a few moments to let you preview your handiwork. If you press the delete button before it goes away, you can remove the image and free up some space on the memory card.

How easy is it to damage these memory cards?

Don't step on them, drop them into water, or leave them in direct sunlight—like on the seat of your car—for hours on end. If you use common sense and take care of your digital film, it'll last virtually forever.

How do I take a black-and-white photo? Do I need a special memory card?

No, you don't need a special memory card. Many cameras have a black-and-white mode that captures pictures in grayscale instead of color. You can just set your camera to black and white before you shoot, but a better solution is to take ordinary color pictures and convert the images to grayscale later on the computer, using your image-editing program (more on that on pages 96–99). That's because you can easily forget the camera is set to black and white, and you can end up taking a dozen grayscale images when you really wanted color.

the two viewfinders

The right place to look

Your camera is kind of like your car. If you want to see what's behind you while driving, you can peer into either the side-view or the rearview mirror. Both are optimized for specific situations, and what you see will be slightly different depending upon which mirror you choose to use.

Your camera is a lot like that—you can use either the **optical viewfinder** (the glass window through the camera) or the **digital viewfinder** (also known as the LCD display, which looks like a mini TV screen). They show you slightly different things, though either will work in a pinch.

Most of the time, the optical viewfinder is probably your best choice. In fact, if your camera allows, you can turn the digital viewfinder off completely to extend the battery life of your camera.

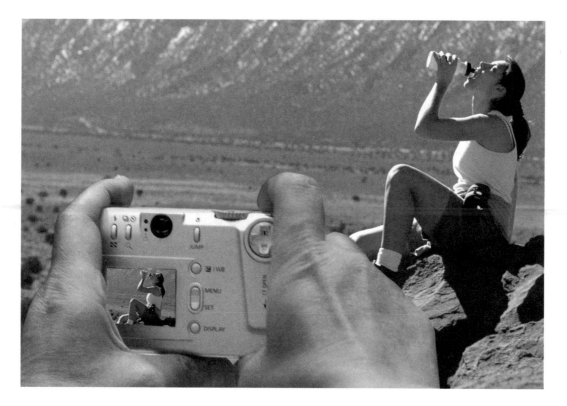

When is the optical viewfinder not the best choice? There are two situations.

1. If you're taking a close-up photo of a small subject like a flower, the optical viewfinder can be misleading. Switch to the LCD display to see exactly what the camera is going to photograph.

2. For fast and loose photography, it's often easier to hold the camera away from your body and frame your shots in the LCD display. It's easier and more comfortable than holding the camera up to your eye.

WHAT IF

The LCD display (digital viewfinder) doesn't come on when you turn the camera on. Why not?

If the batteries are running low, some cameras automatically disable the digital viewfinder to save juice. The camera might also have a preferences setting that determines whether the display is on or off by default. Check your users guide for details.

The digital viewfinder is too hard to see. Can you brighten it?

Most cameras have a brightness setting in the menu system for increasing the LCD display's brightness. Other cameras—like some Epson models—have a lever you can turn to enhance the brightness in sunlight. This setting doesn't work indoors, so be sure to check which position it is set to. Also, remember that many LCD displays are just not bright enough to work well outdoors in bright sunlight, no matter how much you tweak them.

The optical viewfinder is really dark. Is this adjustable?

Some cameras, like the *Olympus Camedia e-10*, electronically assist the optical viewfinder. In other words, the camera needs to be turned on or it won't work right.

two-step to your pictures

Mastering the shutter release

No, it's not a special dance for photographers (though, truth be told, they don't dance nearly enough and a little two-stepping wouldn't hurt many of them). To take better pictures, you should know about the two separate steps that happen when you press your camera's shutter release button. Here's how it works.

1. When you put slight pressure on the shutter release, the camera leaps into action and locks in both the focus and exposure setting (but not the image) based on whatever was in the center of the viewfinder when you pressed the button. As long as you hold your finger in that position, the focus and exposure are locked in, even if you move the camera and point it somewhere else.

2. When you press the shutter release all the way down, the camera actually takes the picture.

Often, photographers just mash down on the shutter release and the two steps happen right after each other. But since it takes some time for step one to occur (on some cameras, it can take as long as a second!), you can get more consistent photos by "priming" your camera with the first step (i.e. getting your focus and exposure set), and then waiting for the magic moment. Frame and compose your shot with your finger slightly depressing the shutter release, then finish taking the picture. That second step will then happen more or less instantly.

1. Gently touch the shutter release to set your focus and exposure settings.

2. Press down the shutter release when you're ready to shoot your picture.

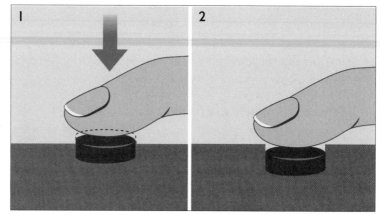

ASK THE EXPERTS

Perhaps I have a lead finger, but my camera seems to take the picture right away when I press on the shutter release.

Well, yes—you might have a heavy finger. Try pressing very, very lightly and see if that has any effect. But it's also possible that you have a camera with a **fixed-focus lens**. This inexpensive, old-style digital camera is pretty rare these days, but if you have one, then it's not your finger. Since the lens doesn't need to focus, the shutter release has but a single step.

If I lock in the focus and exposure but then point the camera in a different direction, won't that make the picture over- or underexposed?

It might, but that might also be an effect you're trying to get on purpose. Lock in the exposure when looking at a bright part of the sky, for instance, and then aim the camera at a statue. The result? Instant silhouette because the statue will be underexposed.

WHAT'S THE POINT?

There are actually a lot of great reasons for having a two-step shutter system. You can use it to lock in the proper focus and exposure before a fast-moving subject roars into the frame, for instance. Or you can prefocus on your kid at a school play and wait for the moment when she smiles just right—then press the rest of the way down on the shutter release to take the picture. If you didn't prefocus, the camera would take too long to capture the shot and you might miss the magic moment.

activating your flash

Here comes the sun

It's Johnny's birthday, and you're trying to take a picture of the birthday boy in a poorly lit room. Do you get a good picture or a bunch of shadows wearing party hats? Your flash holds the answer.

Cameras vary, so be sure to check your users manual. But in general, it's pretty easy to configure your flash. Try one of these two methods.

1. Find the flash button on the camera body; it'll have a picture of a lightning bolt nearby. Press it in and turn the camera's control dial. You should see the various flash settings scroll by on the camera's menu. (See page 24.) Stop when you find the setting you like. Then check in the LCD after the shot to see if it worked.

2. Find the flash button on the camera body (with a picture of a lightning bolt). Every time you press the button, the camera's control panel should display a different flash setting. Stop pressing the button when you find the setting you like.

NSIDE THE CAMERA

With so many flash settings to choose from, which one do you choose? Here's a handy guide to the various flash settings you'll encounter on your digital camera. (For more on using your flash, see Chapter 3, page 54.)

Off This position is easy. When set to off, no matter how badly your camera believes that you need extra light, the flash will not fire.

Auto In this mode, the camera decides when to use the flash.

Force Sometimes called a fill flash, this forces your camera to use the flash even when there's enough light in the scene. It helps to fill in shadows.

Red-eye The red-eye mode fires the flash a few times right before the picture is taken, to allow your subject's eyes to adjust to the light. It prevents that ugly red-eye effect you sometimes see.

Slow The slow flash mode is a special-effects mode that fires the flash once during a long exposure. It's designed to freeze some of the action in a night shot.

changing image quality

You choose how big your pictures will be

As you already know, your camera is capable of capturing images in a number of different **resolutions** or levels of clarity. You can shoot all your pictures at the highest resolution and later crop or resize them to suit your needs, or you can lower the size of your images to fit more on your memory card.

There are two factors you can control: resolution and compression quality. The resolution (or clarity), of course, is the number of pixels in the image. Quality is a bit more subtle. It refers to how accurately you will be able to recreate your picture. High-quality images take up more storage space and print better; lower-resolution images sacrifice some visual quality by compressing the data to squeeze more images on a memory card and your computer's hard drive.

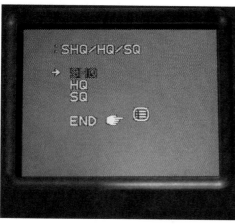

Different cameras use different terms to refer to various levels of quality, but typically you'll see terms like Fine, Standard, Normal, and Basic. It's amusing how camera manufacturers will go out of their way to avoid calling a picture low quality—but if there were truth in advertising in camera specifications, the highest amount of image compression would have to be called low quality instead of terms like Standard or Basic.

To adjust image quality on your camera, look for a button—usually on the side or top—marked Size or Quality. You may also have to enter the camera's menu system (see pages 24–25). Check the users manual for details.

ASK THE EXPERTS

What is the real difference in image quality between a camera's highest and lowest image-quality settings?

The difference in image quality can be hard to see when you're just casually looking at pictures on a computer screen, but the difference might become more obvious when printing pictures you plan to hang on your wall. Also keep in mind that compression artifacts—those messy pixels that occur when a picture is heavily compressed—are more obvious in some pictures than others. For some idea of the difference in high and low image quality with a typical digital camera, compare these two pictures of the same scene.

IMAGE QUALITY

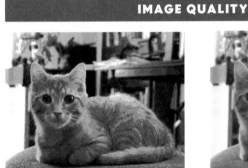

Low JPEG compression quality

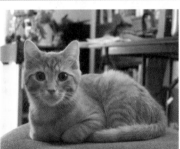

High JPEG compression quality

This chart lists the number of images you can store on an 8MB memory card, depending upon the image size and quality you choose to work with.

	Two Megapixel	One Megapixel	640 x 480*
High	5	19	48
Normal	10	38	91
Basic	20	73	161

*less than one Megapixel

focusing your camera

Bringing things into sharp focus

Your camera's autofocus system is pretty darned good. In a fraction of a second it can usually get a near-perfect lock on your subject—far faster than any human could ever hope to focus manually. But as good as the autofocus system might be, sometimes it needs a bit of help.

If the scene is just too tricky for autofocus mode, you can invoke manual focus. (Imagine yourself as the captain of a spaceship, shouting, "Go to manual!") A few cameras have a knurled lens barrel (in other words, it's bumpy, which makes it easier to grip) that you turn to focus. Most, though, incorporate the manual focus system into the camera's buttons, dials, and levers in the back of the case. To manually focus the *Olympus D-620L*, for instance, you press one of three buttons to select near, medium, and far focus zones. It's fast and efficient. The *Nikon CoolPix 990*, on the other hand, lets you precisely focus the camera by using a pair of buttons to zoom the lens in and out. It's slower, but it affords you a lot more control over the process.

Many cameras also have a compromise solution. If the camera is having trouble focusing, but you don't want to go through the trouble of focusing it manually, you can set it to restrict its focus attempts to just faraway distances—often called a landscape focus mode—or nearby distances, called macro focusing.

SK THE EXPERTS

My camera has focus zones on the viewfinder. What are they for?

Some cameras—particularly Nikon models—let you change the part of the scene that the camera uses to set the focus. Suppose you're taking a picture of two people, for instance. The center of the viewfinder is a space between them, and thus the camera might focus not on them but on the background. A camera with multiple focus zones might let you tell the camera to focus on the right or left side of the scene.

I want to enter manual focus mode, but the camera won't let me. Why?

You're probably in the camera's auto mode. You need to spin the control dial on the top of the camera to its manual mode. In manual mode, you have complete control over the camera's exposure and focus.

Is there an easier way to tell if my subject is in focus in the digital viewfinder?

The LCD display (the mini TV window also known as the digital viewfinder) does make it hard to see if something is in focus. Look for a focus confirmation tool in your camera's menu system. This feature highlights those objects in the digital viewfinder that are in sharp focus.

zooming into action

Get up close
and personal
with your lens

It's the ideal photo tool. A zoom lens allows you to get close to faraway events, or enlarge nearby scenes, without moving your body at all. But not only does a zoom lens simply bring things closer, it changes the way the scene looks.

When your camera is zoomed out all the way, it's in wide-angle mode. We don't usually see the world that way—our eyes have a narrower visual perspective—and as a result, wide-angle shots have a real sense of space and depth. Zoom in a bit and you get to the "normal" perspective of human vision. But keep going to telephoto, and the world looks squished. The foreground and background in telephoto shots are compressed, making it hard to tell how much space there is in an image from front to back. There's also less depth of field available, so the background is probably going to be out of focus in most zoomed photos. By experimenting with the zoom, you might find that there are a lot of artistic possibilities aside from just the mundane "magnification" role that zooms usually play.

FIRST PERSON DISASTER STORY

Trouble Focusing

A friend lent me his digital underwater camera so I could take pictures the next time I went snorkeling. It was an impressive rig—a three-megapixel digital camera in an underwater housing, usually used for scuba diving. I was diving in south Florida and anxious to capture pictures of all the wondrous sea life, including the endangered manatees that lived in the area. Unfortunately, when I was under water, I simply couldn't get the camera to focus. No matter how hard I tried, the camera's autofocus system wouldn't "lock on" to anything I pointed it at. And without good focus, the camera wouldn't take any pictures. It wasn't until the end of the day that I figured out what was wrong. The camera was zoomed all the way in to telephoto mode, and the camera has trouble focusing in that mode—especially under water. I learned a very important lesson that day that applies even on the surface. If you're having trouble getting a good focus, zoom out first. Then zoom in on your subject and take the picture.

Ralph M., Staten Island, New York

WHAT IF

Your zoomed images look grainy and blurry. What happened?

You're probably using the digital zoom mode of your camera. When you press the zoom button, it's your optical zoom that goes into action, just as on a traditional camera. However, when you reach the limit of the optical zoom range, the digital zoom kicks in. You can usually tell when the digital zoom is working because instead of the fluid, smooth zoom effect you get with the camera's optics, the digital zoom enlarges the scene in discrete, jerky jumps. The digital zoom just magnifies the pixels (color dots) in the center of the CCD (the light-sensitive computer chip that forms the image), and the result is grainy and ugly. Turn off the digital zoom or avoid using it. If you really need more magnification, you can get it when you transfer your image to your computer.

Your pictures have a dark border around them. What is it and how can you get rid of it?

Certain lens attachments can extend so far away from the lens that they block light and create a dark border around the edges of your picture. This is called **vignetting**. It's common with telephoto lens attachments for digital cameras. If you're using a zoom lens, you may find that only certain positions—like zoomed all the way in or all the way out—will suffer from this ill effect. The easiest solution is to avoid using lens attachments that cause vignetting, but you can also just make a note of when vignetting occurs and avoid setting the zoom to those positions when using the attachment.

making short movies

Lights, camera, action! Many digital cameras are multitalented—not only do they shoot still images, but they're able to take short movies as well. If you have such a camera (it will have "movie mode" as one of its settings), you can add short video clips to your Web site or e-mail movies to friends and family.

To become a virtual Steven Spielberg, just set your camera to movie mode, which usually looks like a movie camera and appears alongside the symbols for your camera's record and playback modes. Once there, just press the shutter release to start filming. You will only have a short time to make the movie—typically less than 30 seconds—so you aren't making a three-act play. You'll have time to say a few words—yes, it can record sound too—pan around the scene, or have your subject show off her new tap dancing steps. To stop filming, press the shutter release a second time or just let it use up all the memory on its own.

The finished movie appears on the memory card—along with your still images—in the form of an **MPEG** (or compressed) movie file, which is playable on any computer. It is a highly compressed sound-and-video file that you can drop into an e-mail message as an attachment or store on your PC's hard disk.

LOCATION **BACKYARD**
TAKE **3** SCENE **1** DATE **10/2**
DIRECTOR **Anne**
CAMERAMAN **KRAMER**

SK THE EXPERTS

Why is my movie so jerky?

That's the nature of MPEG. You can get smoother results by moving the camera more slowly—or not at all—when filming. The less movement you introduce into your movies, the smoother they will look.

What can I do to make my movie file easier to e-mail?

Obviously, the shorter your movie, the easier it will be to e-mail. But you can also minimize file size by keeping to a minimum the amount of change from one frame in your movie to the next. If you're filming someone who is standing still, for instance, put the camera on a tripod so the background doesn't move. You can also try to keep the lighting consistent, so if you move the camera, the scene doesn't go from very dark to very light.

Can I somehow grab a still image out of an MPEG movie I shot?

Not really. MPEG is a special graphics format that doesn't like to be taken apart. More important, though, the resolution of MPEG is low, and individual frames would look terrible. Even if you could dissect an MPEG movie, you wouldn't want to.

shooting a panorama

Capturing breathtaking vistas

It's hard to capture the sheer majesty of the New York City skyline in a picture that's only four inches across. That's why some photographers love to take panoramas—wide pictures made by combining a sequence of photos. Thankfully, panoramas are really easy to do on a digital camera. Follow this two-step process.

1. Take a set of pictures.

2. Use a panorama software program on your PC to automatically combine your pictures into a finished product. You can use either MGI PhotoVista or PanaVue ImageAssembler (see page 126). Completed panoramas can be printed or posted to a Web site.

To make a panorama, overlap each successive picture by 25%.

To take a panorama, set your camera on a tripod to keep it level and take your first shot at the right-most edge of your vista. Then turn the camera slightly to the left so the next image will pick up where this first one left off. Make sure that about 25 percent of the left side of the first image becomes the right quarter of the next shot. That overlap will help the computer assemble the pictures properly into a seamless panorama.

 # MAKING IT EASIER

You don't need any special tools or gadgets to make your own panoramas—but it doesn't hurt. If you really like making them, you may find these suggestions helpful:

Get a digital camera with a **panorama mode.** Some cameras have a special panorama mode designed expressly to help you shoot a sequence of overlapping pictures. Using a guide on the LCD display, the panorama mode shows you where to overlap the pictures.

Get a **rotator plate** for your tripod. You can get a rotator plate for your camera that lets you spin it like a lazy Susan. Some even have little indents to help you know where to stop to get the right overlap in a panoramic sequence.

now what do I do?

Answers to common questions

What do I need to know to be sure that a digital camera will work with my computer?

Check out the system requirements that are listed on the camera's box. The manufacturer should list any criteria your computer needs to have to work correctly. Because your camera will work just fine on its own without the computer, though, the key is usually that the computer has the right hardware to synchronize with the camera to transfer images and enough speed and hard-drive space to run any image-editing software that comes with the camera. The box will usually specify the operating system needed—like Windows 95, Windows 98, or a Macintosh OS. Your computer may also need to have a serial port or a USB port for transferring images from the camera to the PC. (The cable that connects the camera to your computer should be included with your digicam.)

Why would I want to shut off my flash? Isn't the flash smart enough to shut itself off in bright light?

Yes and no. What you want to avoid are situations in which the flash might fire when it really, really needs to be turned off. Like when you're taking pictures in a museum with signs that say "no flash photography." Or when you're shooting into a window and the flash would reflect off the glass, completely ruining the shot.

I think my memory card is broken. How can I tell if it's the card or something I'm doing wrong?

Your memory card is a pretty robust little guy—so odds are good that something else is amiss. Maybe your camera's batteries need to be replaced, or perhaps there's a software conflict somewhere with your computer. The easiest way to figure out if the problem is in the memory card—try the memory card in a different computer. If it works anywhere, the memory is fine. If you have a **memory card reader** (a floppy-disk holder) for your computer, for instance, try to copy files between the card and your computer.

I've seen some amazingly large memory cards out there, like the 1 GB IBM Microdrive. Should I consider using one of them to store a lot of pictures?

While the idea of storing as much as a gigabyte of images (that's hundreds of pictures!) is attractive, watch out. First of all, the Microdrive is a Type II version of the Compact Flash card. Not all cameras that use Compact Flash can accommodate a Type II card. Check your users manual. Even if your camera is compatible, remember that the Microdrive is a mechanical device. It's a tiny hard disk. And because of that, it has a much higher failure rate than ordinary memory cards. That means you could lose a lot of work all at once if you drop the card or it breaks on its own.

Do all cameras have both automatic and manual features?

No. Most low-end budget cameras dispense with all the manual stuff. If you want to be able to take control of your camera and set special exposure or focus settings, you'll need a performance camera. Be sure that whatever camera you plan to buy is flexible enough to keep you happy.

OW WHERE DO I GO?!

CONTACTS	PUBLICATIONS
The Digital Camera Resource Page **www.dcresource.com**	**How to Do Everything** **with Your Digital Camera** By Dave Johnson

Taking great pictures

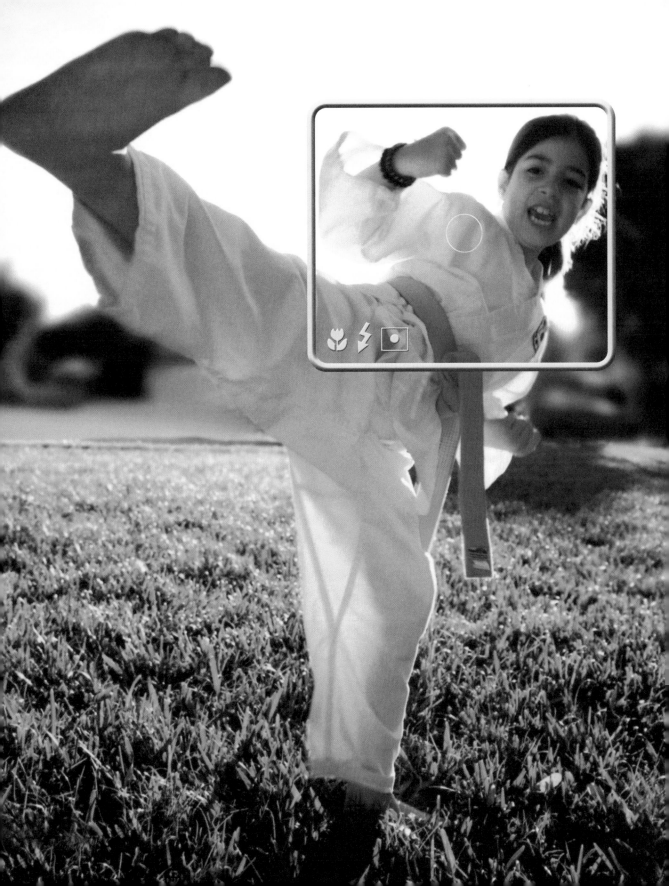

mastering composition

Developing the eye of a photographer

Photography is half art and half science. The science part is easy—it's all about shutter speed and aperture size and light and digital data. But developing an eye for good pictures takes practice—and an understanding of the rules of composition. If you keep the rules in the back of your mind and try to apply them when you shoot, your photos will probably improve dramatically.

Start, for instance, with the rule of thirds. If you draw four imaginary lines—like a tic-tac-toe grid—through your picture so your scene is divided into thirds both horizontally and vertically, your main subject should lie at one of the points where the lines intersect. That's more interesting than placing something in the center of the picture.

The rule of thirds is a powerful way to make your pictures exciting. But consider some of these tips as well.

■ Get close—fill the scene with your subject instead of taking a picture from a long way off.

■ Emphasize the subject by making the background out of focus. You can change the camera's aperture setting to reduce the depth of field, which is a term that refers to how much of the scene is in focus. Read more about this technique later, on pages 56–57.

■ Look for lines—like roads or a shoreline—to draw the viewer's eyes through a picture.

EYE ON COMPOSITION

After you get the hang of these tips, feel free to break the rules! Take pictures from unusual perspectives. Try your hand at abstract images. It's art, so have a blast trying out new things.

using the flash

When to use all those fancy flash settings

The poor little flash is probably the least understood, most misused part of any camera. It tries its best, but the fact remains that your flash needs your help.

The best place to start is with the range of your flash unit. It probably works for no more than about 15 feet, so anything beyond that range won't be illuminated. If you're shooting a subject that's so far away that you won't need the flash, you can extend the life of your batteries by turning the flash off. You'll know it's off if the flash display has a slash through it. (If the flash icon simply disappears in your camera's display, it's not turned off—that probably means it's set to fire automatically.) Also turn your flash off when shooting through glass, since the light will otherwise just reflect back into the lens, ruining the shot.

If you're photographing people, especially indoors, turn on the camera's red-eye reduction mode (it looks like an eyeball in the display). The camera will "preflash," adjusting your subject's eyes to the bright light, and eliminate the evil-looking red-eye effect you've probably seen in snapshots. And remember to turn off the red-eye mode when you don't need it, since it uses extra juice and adds a delay between the shutter release and when the picture is taken.

Lastly, you can use the flash's force-flash mode. The flash fills in shadows on your subject's face caused by sunlight.

ASK THE EXPERTS

When would I want to use the Slow setting on my flash?

It's best at night. This setting combines a flash with a slow shutter speed. Suppose you want to take a picture of friends in front of your Las Vegas hotel. The flash illuminates your friends and freezes them, while the slow shutter speed captures the hotel lights in the background. You can even use this mode to get the motion blur of passing cars in the picture.

switching exposure modes

Choosing the right exposure for your pictures

We live in an automatic world. Automatic transmissions. Speed dial phones. Self-cleaning ovens. And automatic digital cameras. Most of the time, the automatic mode on your camera is perfectly able to capture the scene in the viewfinder. But there are situations when taking the camera off automatic is just the ticket for capturing the perfect picture.

Many cameras offer something called aperture-priority and shutter-priority settings in addition to the standard automatic setting. **Aperture priority** gives you the ability to control the size of the aperture—the diaphragm that lets light through the lens—while the camera selects the matching shutter speed. The aperture is important because its size determines the depth of field of your picture. In

other words, it sets how much of a scene besides the subject is in focus. Larger aperture numbers, like f/8 or f/16, correspond to a deep depth of field with lots (or all) of the picture in focus. A small aperture number, like f/2 or f/4, is just the opposite—a narrow depth of field in which only the subject is in sharp focus.

Shutter-priority mode gives you control of the length of the exposure, while the camera selects the matching aperture. The shorter the shutter speed, the more likely you are to freeze fast action. A long shutter speed (best used with a tripod) can give you blurred motion.

 SK THE EXPERTS

Is there any way to see the effect of changing aperture or shutter speed before I take the picture?

If you're tweaking the aperture to change the depth of field (i.e., how much of your picture is in focus), you can see the results instantly in the LCD viewfinder (the mini TV screen which shows exactly what you are photographing) before you take the picture. Don't look in the optical viewfinder, though, because the aperture setting has no effect on that. But if you're varying the shutter speed, the only way to see how sharp or blurred your picture will be is to actually press the shutter release and see the result.

APERTURE TRIVIA

You may never need to know this, but the aperture numbers are actually a measure of the ratio of the diameter of the diaphragm opening to the focal length of the lens. (And you thought you finished algebra years ago.) An aperture value is called an f/stop. See below for what the f/stop means.

f/2 = small number = big lens opening = small depth of field

f/16 = big number = small lens opening = big depth of field

handling unusual lighting

How to outsmart the sun

Cameras are a bit fickle. You already know that a certain combination of shutter speed and aperture will give you the right exposure for your pictures. Most of the time, you don't even have to think about figuring out what the right exposure is—just set to "auto," and your camera does all the work. Or, when using a priority-program mode, you only need enter the shutter speed or aperture and the camera does the rest. But sometimes taking a picture that way will disappoint you. Certain lighting, like shooting into the sun, can confuse the camera's exposure meter and ruin the shot.

If you snap a picture and check the LCD display on the back of your camera only to discover that the picture you just took is way too dark or much too light, don't panic. After all, that's the magic of owning a digital camera—you can tell immediately if you need to shoot it over.

You can correct **underexposure** (not enough light in the image) or **overexposure** (too much light) with your camera's **exposure-compensation control** (usually referred to as the EV setting).

A little practice with the EV control and you can adjust your exposure like a pro. If your picture is too dark, you need to set your EV control to about EV +1 and try again. Most cameras let you adjust the EV setting in one half or one third EV increments, so you might need to try a few shots before you zero in on the right setting. Likewise, if the image is too bright, dial in an EV –1 and see if that improves the shot.

SK THE EXPERTS

I've heard that using a different exposure meter can solve the problem with over- or underexposure. Is this true? How do I do that?

Most cameras use what's called a center-weighted light meter, which pays more attention to the light in the middle of the scene than on the edges. A newer, better kind of meter is called a matrix meter, which does a lot of fancy math to measure light from all over the scene and come up with a better exposure. It's harder to trick a matrix meter with weird lighting, so you can avoid the EV control more often with that kind of meter. Newer cameras from companies like Nikon and Olympus come with matrix meters.

Center-weighed light meter

Matrix meter

taking great night photos

City lights make excellent pictures

When the lights go down, most people put away their cameras. But you're not like most people—and night photography is a fun and rewarding way to use your digital camera. At night, you can take pictures of city lights, the trails of car headlights streaming down the road, the moon, and more.

The key to night photography is a long exposure. Depending upon what you choose to photograph, it'll probably take a longer exposure than what the camera's automatic mode suggests to get a good shot. You have two choices.

1. Use the EV control to extend the camera's automatic exposure. Set the camera to EV +1 or EV +2 for starters and see what you get. In most cases, the longer the exposure, the better your results will be.

2. Set your camera to shutter priority or its full-manual mode and dial in a shutter speed of 2, 4, or 8 seconds.

SK THE EXPERTS

It's really difficult to hold the camera still when taking a long exposure. Can I attach a tripod to a digital camera?

Yes! You should support any exposure longer than about 1/60 second with a tripod. You don't need a large or expensive tripod, since digital cameras are quite small and light. But all digicams have a tripod socket on the bottom, so you're in business.

How do I know which exposure to use at night?

The good news: it's a matter of personal taste. Generally, the longer you expose the picture or the more open the aperture, the brighter the lights in the scene will be. And there's a big range of exposures between underexposed and overexposed, so you can get good results with lots of different shutter speeds. Try to start with the camera's suggested exposure and overexpose that by one or two EV values. Check your results and experiment.

getting close

Shooting the tiny world around you

Close-ups aren't just for movie stars. Close-up photography, also called macro photography, is surprisingly easy to do. You can use your digital camera to photograph your collectibles (like stamps, coins, or antiques) or even do nature photography in your own backyard. All you need is a tripod and a macro setting on your camera.

The macro mode is usually activated by a button or menu item (see page 24), and it's indicated by a symbol that looks like a tulip. Macro mode enables your camera to focus very close, usually within a few inches of the subject.

Close-ups magnify the subject, so that even small objects, like coins or insects, fill up the frame. You'll need a tripod for macro shots because the slightest shake results in a blurry picture. Also, keep in mind that at such small distances, the camera's depth of field is miniscule—less than an inch, in fact. So arrange your shot so the subject—or at least the most important part of the subject—is in sharp focus.

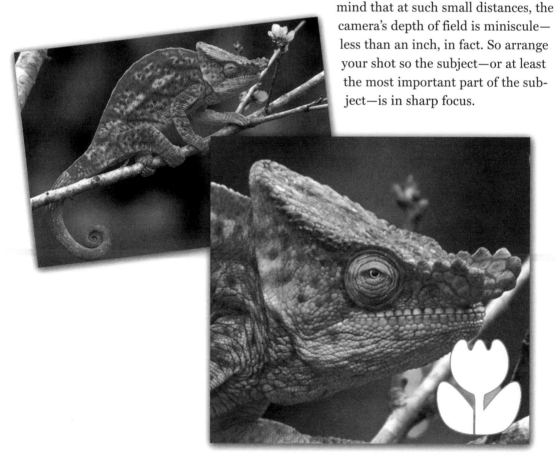

STEP BY STEP: TAKING A CLOSE-UP PHOTO

1. Set the camera on a tripod and position it near the subject.

2. If you're shooting an artificial subject, like coins, you might try placing them on a foam board or some other solid-colored background. If outdoors, and you have an assistant, have someone block the wind with a large piece of poster board.

3. Turn the camera on and set it to macro mode.

4. If you're shooting outdoors and there's plenty of light, disable the flash to help maximize depth of field.

5. Frame the scene and press halfway on the shutter release to focus the image.

6. If the subject is properly focused in the LCD display (the little TV on the back), take the picture. If not, you might be too close—back the tripod away from the subject and try again.

CROPPING TO ENLARGE

If your camera won't focus closely enough to fill the frame with your small subject, take the picture from farther away, then crop the image down to size on your computer. (More on how to do this on page 102.)

capturing the action

**You too can be a
sports photographer**

Whether you're shooting pictures of a school football game or a NASCAR auto race, action photography is fun and rewarding. You can probably guess the main ingredient in most action shots—a fast shutter speed. That's why you should set your camera on shutter priority, if your camera has such a setting, before you take your first action shot. Always try to take the picture at the highest shutter speed available, to freeze the action. The aperture setting is usually not that important in an action shot, and a fast shutter speed has the effect of reducing the depth of field anyway—which is usually pretty good, since it isolates your subject from the background.

Another thing to consider: your camera's lag time. Since each picture you take must be stored on the memory card before you can take the next shot, there's usually a delay of several seconds while you wait to be able to take another picture. If your camera has an action mode that lets you take several pictures at once before writing the images to memory, use that mode instead.

FIRST PERSON DISASTER STORY

The Long Delay

All I wanted to do was shoot my son's first soccer game. I took our brand-new digital camera to the school's soccer field and started snapping away. What I got was anything but what I wanted—lots of pictures of empty space, half of my son's head, and people that were almost in the frame. What I discovered (too late for that game) was the amount of time it takes to actually snap a picture with my camera. It takes about a full second from the moment I press the shutter to focus and snap the shot. So by the time the picture was taken, I had lost the shot in almost every case. The trick, I've learned, is to prefocus by pressing the shutter halfway down and keep panning around with the action. When it looks good, finish pressing the shutter release to take the shot.

Eileen B., Santa Maria, California

SHOW ACTION WITH MOTION BLUR

Instead of freezing the action with a fast shutter speed, you can show how fast something is moving by slowing down the shutter and letting the subject blur through the scene. With a shutter speed of about 1/30 second, you can either hold the camera still and let the subject blur, or follow the subject with your camera and let the background blur. Both techniques add up to fun and exciting pictures.

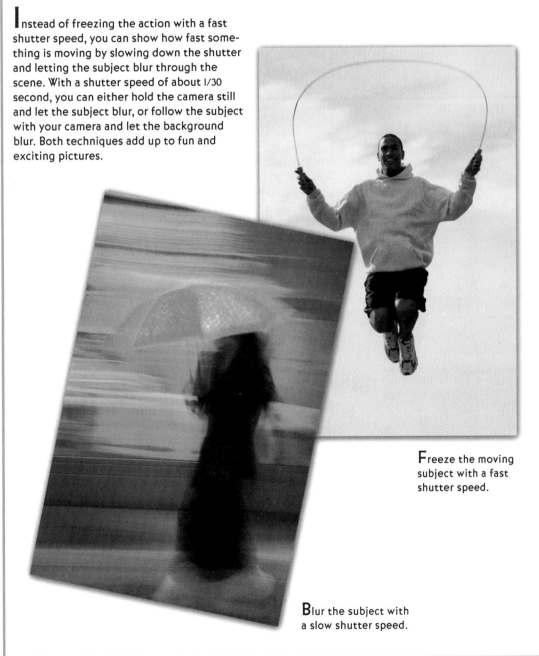

Freeze the moving subject with a fast shutter speed.

Blur the subject with a slow shutter speed.

taking portraits

Say cheese!

What scene better captures the essence of photography than asking someone to pose in front of the camera? The expression "Smile and say cheese!" has been around almost as long as the camera itself.

To take a good portrait, having the right light is important. Portraits work best outdoors, where the sun can provide your primary lighting. Position the sun to your left or right side, so your subject's face is illuminated, but the person doesn't have to squint into a giant ball of celestial fire—and can therefore look more comfortable and natural. Turn on your camera flash and set it to its force (or fill) mode so it'll eliminate any harsh shadows caused by the sun (below right). And finally, zoom in about as far as your camera's zoom lens will allow you to go. That'll set your camera to a focal length of about 100 mm, the most natural setting for portraiture.

Too many shadows?

Eliminate shadows by using your flash.

ASK THE EXPERTS

Where should the subject look when I'm taking a portrait?

Some of the best portraits happen when you have the subject look just off to the side. Ask your subject to look toward you, but not directly into the camera. For young kids, it's a good idea to jiggle a toy above the camera. That not only gets them to look in the right direction, but they'll smile as well.

Can I take one of those fancy silhouette-style portraits with a simple digital camera?

Yes, you sure can. One of the easiest ways to get that effect is to position someone in front of a well-lit window or outdoors near the setting sun. When you take the picture, focus-lock (press the shutter halfway down) while pointing the camera at the light, not the subject. Then position the camera at the subject and finish pressing the shutter down to take the picture. The subject will be underexposed and silhouetted.

UNCLUTTER THE BACKGROUND

The backdrop is an important element in any portrait. Natural settings are the easiest. Ask kids to lean against monkey bars at the local playground, for instance. Stand your family against a backdrop of trees. Sit a friend down on a rock overlooking a pond or on a sloping hill of grass. If you want to take the picture indoors, minimize clutter. Take the shot by a curtained window, against a plain wall, or beside a piece of antique furniture. But don't take the shot with a crowd of people or a roomful of furniture behind them.

now what do I do?

Answers to common questions

Does the advice in old photography books and magazines apply in the digital age?

Anything you read about composition and framing your 35-mm photos is just as true today as it was when it was first written. Most of the advice about exposure still holds true too—like tips on how to take a good sunset or how to shoot pictures of people in bright light at the beach. The only advice that won't make much sense for digital photographers is stuff that's peculiar to certain kinds of film or how to handle specific cameras.

How do I illuminate a dark scene if I'm shooting through a window?

That's a good question, because using the flash through glass will just make a reflection and ruin the shot. Your best option is simply to brace the camera (on a tripod, if possible) and shoot the picture with a long exposure.

I can edit my digital pictures on my computer, right? With all the automatic color and exposure correction wizards built into image-editing programs, should I care if the exposure is a little off when I take the picture?

If it's a little off, no—that's why those image-enhancement tools exist on your computer's imaging software. But you won't want to fuss with every picture, and the best software in the world can't fix a badly over- or underexposed picture. So you should try to master the basics and take good pictures right from the outset.

Where can I buy a tripod for my digital camera?

If you already have a tripod for your old 35-mm camera, you can use it for a digital camera. The mount for the tripod is a standard size for all cameras—digital too. If you need to buy one, you can find one in most camera stores.

What's the best way to improve my photo skills?

Take a lot of pictures. The more you shoot—especially if you consciously think about your technique—the better you'll get. Also, show your finished images to people and solicit their feedback. Finally, enter photo contests. There are lots of local and national competitions that will help you see how you compare to others.

I'd like to enter a photo contest, but they require entries on slide or negative. Does that mean I can't enter a digital image?

No, it doesn't mean that unless the rules specifically say that digital images aren't allowed. For a few dollars, you can have a digital image turned into a high-quality 35-mm mounted slide at your local camera shop.

NOW WHERE DO I GO?!

CONTACTS	PUBLICATIONS
DigitalFoto Magazine 415-468-4684 **www.imaginemedia.com**	**Digital Photography for Dummies** By Julie Adair King
Digital Camera Magazine 516-349-9333 **dcm.photopoint.com/dcm/subscribe.html**	

CHAPTER 4

Moving pictures to your PC

installing software

**Getting ready
to use
your computer**

Remember when you opened your digital camera box for the first time? You found the camera, a memory card (also known as digital film), some users guides, a computer cable, and a little Frisbee. Actually, that Frisbee is the CD-ROM that's packed with software to help you use your camera. The disk itself—or perhaps its casing—should list all of the applications (a techie term for computer programs) that you'll find on the disk to help you transfer your images from the camera to your computer. There may also be a few extra programs, like an **image editor** that you can use to modify or improve your pictures, or a **project program** that lets you incorporate your pictures into greeting cards, T-shirts, newsletters, or other fun activities.

That's great, but you need to get your software installed on your computer before any of the fun can begin. And osmosis doesn't work—you can't just hold the disk close to the computer and hope for the best. Actually, it's a snap to load these programs onto your PC. See the next page for blow-by-blow instructions.

STEP BY STEP: INSTALLING YOUR SOFTWARE

1. Turn your computer on and wait for the operating system to finish booting up (or starting).

2. Open the jewel case or paper slip package that the CD-ROM came in. Check to make sure you've got the right disk. Some digital cameras come with two disks—one for a Macintosh computer and another, for Windows, that works with PCs.

3. Then, on your console or tower, press the button on your CD-ROM or DVD drive to open the door and wait for the tray to pop out.

4. Place the CD, label side up, on the tray and push the button to close the tray.

5. At this point, the computer will most likely start installing the CD's software automatically. If it doesn't, double-click on the My Computer icon on your desktop screen and find the icon for your CD-ROM drive—then double click that as well. Find an icon called Setup or Install and double-click it. The computer should now start to install the software. It will ask a few questions. When in doubt, just accept whatever default options the software wants to use.

6. When the installation is complete, remove the CD-ROM. You should restart your computer (click on the Start button, and when the menu pops up, choose Restart) to let all the changes take place.

7. Store the CD in a safe place in case you need it again.

connection cables

The most common—but certainly not the only—way to transfer images from your digital camera to a personal computer is by using a connection cable. All digital cameras come with some sort of cable (serial or USB—for more on this see next page: What's Out There) right in the box to let you copy the images to the PC.

Perhaps the hardest part of using a connection cable is sharing the limited number of **ports** (the holes where you plug stuff in) on your PC with the camera and other devices—like a modem, Palm organizer, or a printer—that might need the same connectors. Worse, those connectors, or ports, are usually around the back of the PC, making it a pain in the neck to connect and disconnect them on a regular basis. There are a few quick fixes to this quandary. If your camera comes with a USB connector cable, for instance, you can buy a USB hub that'll give you four extra connections. USB hubs can sit on top of your desk for easy access. They are available at most computer stores. Another option: if you're in the market for a new computer, look for a model that puts some serial and USB ports right in the front of the computer. That makes it easy to get to them without yanking the computer away from the wall.

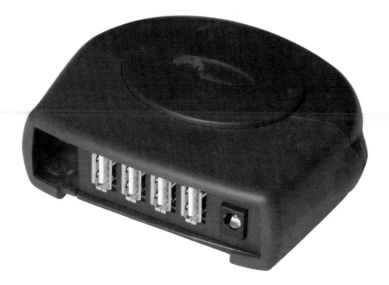

HAT'S OUT THERE

You will find that there are two kinds of connections for digital cameras. Here's what your options are.

Serial Older cameras and some less expensive cameras come with serial connector cables, which work both with older operating systems, like Windows 95, and with the newer systems as well. You should avoid serial if you can, though, since it's very slow. It can take a half hour to copy a camera full of images to your computer!

USB Most new digital cameras come with USB cables. They transfer your pictures to the computer very quickly—ten times faster than serial. Even better, you can insert and remove the USB cable when the computer is turned on, something you shouldn't do with serial. Plus, USB is smart enough that when you turn on your camera, it can usually recognize what you're trying to do and automatically start the image transfer software for you. The downside? You must have Windows 98 or newer (like Windows Me or XP) to use USB. If you're still using Windows 95, you need serial.

MAC COMPATIBLE?

If you have a Macintosh, make sure any camera you're thinking of buying has a Mac-compatible way of transferring images to the computer before you purchase it. In general, serial cables work with both Macs and PCs—but check the system requirements on the box to be sure.

memory adapters

While your camera came with a connection cable that you can use to copy your images to the PC, there's an easier way—a **memory adapter**. One kind looks like a floppy disk but has an opening to accept a memory card. Using this memory adapter, all you have to do is take the memory card (also known as digital film) from your camera, insert it into the adapter, insert the adapter into the floppy drive, and then drag and drop the images wherever you want them to be on your PC's hard drive. Other adapters are similar in size to a disk but need a cable to connect to your computer. It's just like copying files from a floppy disk, and you don't have to work with confusing transfer software.

Memory adapters are typically optional equipment. A few cameras ship with an adapter right in the box, but for the most part it's an extra expense. It can be well worth the money, though, especially if you take a lot of pictures.

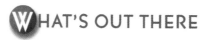HAT'S OUT THERE

There's a memory-card adapter out there for every kind of memory card. No matter what kind of digital camera or memory system you have, you can find an adapter to make it easier to copy images to the PC. The two most common kinds of memory adapters, though, are designed for Smart-Media and Compact Flash memory systems.

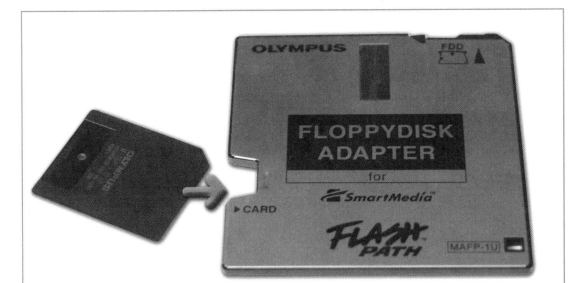

SmartMedia adapters

These are really neat because they fit in your floppy disk drive. That means you can transfer images to the computer just as easily as if they were on a floppy to begin with.

Compact Flash adapters

There are a bunch of Compact Flash memory adapters out there. Usually, these adapters use a cable to connect to your computer. You insert the memory card into its slot to transfer images to the PC.

transferring your pictures

Getting pictures out of your camera

Your pictures don't do you a whole lot of good if they're stuck in your camera. Armed with either a connection cable or a memory-card adapter, though, you can effortlessly transfer your images to the computer, where they can be edited, stored, posted to a Web site, or printed.

No matter what kind of camera you have, the process of transferring your images is essentially the same. Assuming you've already installed the software on the CD-ROM that came with your camera (if not, see page 73), start by attaching the connection cable to your PC and camera. Then turn the camera on. If you are using a memory-card adapter, take the memory card out of the camera and insert it into the adapter instead. Then start the image-transfer software that you've installed from the CD-ROM. Typically, to do this, you'll click Start, Programs and find the software from there, but the program's exact name and location will vary. You should see the images on the computer screen; select the ones you like and drag them to a folder on your PC.

When you're all done, you should erase the memory card so you can start over again and take new pictures. (See page 25 for erasing memory cards.) Remember: transferring images only copies them to your computer—it doesn't erase them from your memory card.

STEP BY STEP: TRANSFERRING IMAGES WITH A CABLE

1. With your computer turned off, attach the cable to the appropriate port on your PC. (If you're using a USB cable, you can leave the computer turned on.)

2. Turn the computer on and let it completely start up, until you see the desktop and the hourglass disappears. Then you can go on to the next step.

3. Insert the other end of the connection cable into the camera.

4. Turn the camera on. Some cameras have to be set to a particular mode to transfer images, such as the Playback mode or a special Transfer mode. If there's a special transfer mode on your camera, set it to that mode now.

5. If your software is reasonably smart, it'll start as soon as it senses the camera at the other end of the connection cable. If it's not so smart, you'll have to start it manually. (Typically, click Start, Programs, and find it from there.)

6. After the program is running, you should see a list or set of thumbnail (i.e., tiny) images of all the pictures stored on the camera. Select the images you like. One way to do that is to hold down the CTRL key on your keyboard and click on each image you want. They should stay highlighted as you make your selections.

7. Open a folder on your PC where you'd like to keep these new images. You can double-click on the My Documents folder on your desktop, for instance, to open that.

8. Click and drag the group of selected images from the camera's folder to the new location on your computer's hard drive.

viewing your pictures

Seeing your shots

Congratulations . . . you've moved your pictures from the camera to your computer. Now you can finally see your images in their full glory—not just on the tiny LCD screen that's on the back of your digital camera.

Once your pictures are on your PC, they're treated just like any kind of data file. You can view the pictures in any program that handles graphics files—an image editor, photo album, even a Web browser or your word processing program.

The easiest way to see your pictures, though, is with a handy little Windows tool known as Quick View, which lets you see a picture right on the desktop. To do that, open a folder and right click on an image file. You will see a menu appear—choose Quick View from the menu, and the image should appear a moment later.

You can also double-click on an image file. Windows will then automatically open the image in a program—probably an image editor—on your screen. The advantage of Quick View, though, is that it's faster and uses fewer of your computer's resources.

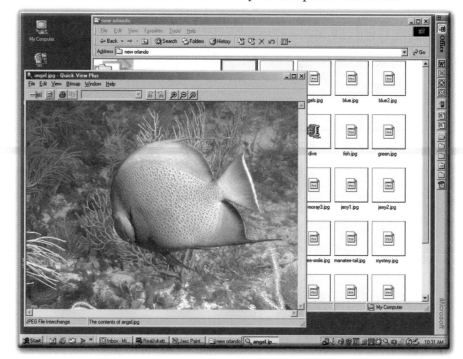

ASK THE EXPERTS

I don't see Quick View in my menu when I right-click on a graphics file. Why not?

You might be using Windows Me. If you are, you need to do it a bit differently: right click and choose Open With, Image Preview. If you're using Windows 95 or 98, then Quick View is in your computer, but may not be installed. You can do that yourself. Choose Start, Settings, Control Panel, and double click on Add/Remove Programs. Click on the Windows Setup tab and double click on Accessories. Finally, find Quick View from the list, select it, and click OK. It should then be installed for you.

What if the picture is too big for my screen?

Don't worry about that for now. When you are ready to e-mail, print, or otherwise share your image with someone, you can resize it for whatever purpose you have in mind. (See pages 138–139.) For now, you're seeing it at the size your digital camera captured it, and you can scroll to see the parts not immediately visible.

organizing pictures

Finding your pictures when you need them

After you've had your digital camera a while, you'll start to accumulate a whole lot of pictures on your PC. And when you want to find a specific shot—like that one of Bruce at the Grand Canyon last summer or Jackie on her birthday—you might get the idea it's like finding a needle in a haystack.

Well, it doesn't have to be that way. Your digital images are actually pretty easy to organize. A lot easier, in fact, than your old slides and negatives (which are clogging up a few dozen shoeboxes in the garage, no doubt). The key is to use a program that lets you display your images using thumbnails, which are small versions of the actual images. That way you can work with your pictures visually, not just by name.

Also, be sure to rename your pictures right away, as soon as you transfer them to the PC. Your camera names pictures awful things like DSC0002302.JPG. So before you have a thousand pictures with names like that, right-click on each image and choose Rename from the menu—then give your pix any kind of descriptive name you like and date them too.

HAT'S OUT THERE

There are lots of software programs out there that let you view, sort, and organize your digital pictures visually. Here are four you might want to check out.

FREE SOFTWARE

Windows 98

Open a folder with images and choose View As Web Page from the menu at the top of the folder. Then click on an image file and you will see a thumbnail view of your picture.

Windows Me

If you have the Windows Me operating system, it's all you need. This latest version of Windows includes a very cool feature—a folder called My Pictures. Any images you store in that folder will be automatically displayed as thumbnail (tiny) images, making it easy to see what you've got. And it doesn't cost a dime!

SOFTWARE YOU HAVE TO PURCHASE

Image Expert 2000

This very-easy-to-use image-editing program displays all your pictures with little thumbnail views. But it also lets you assign "keywords" to each picture—so you can associate the words holiday, Christmas, present, and tree with a picture of your Christmas tree, then months later find the picture by typing any of those words into the program. That's great if you have thousands of images stored on your computer.

Paint Shop Pro

This image-editing program is great for making changes to your pictures. But it has a Browse feature built in that makes it handy for organizing images too. Browse opens a window full of thumbnails of all your images, kind of like the way Windows Me and Image Expert work. As a bonus, though, Paint Shop Pro is an excellent program for tweaking your images. Using this program, you can easily crop your pictures, resize them for printing, add fun special effects, and even combine text with graphics. (For more on these very cool features, see Chapters 5 and 6.)

file formats

The ABCs of digital image files

Hey! This sounds suspiciously like a chapter from some stuffy computer book. What gives?

Actually, file formats, which refer to the way information is stored, are an essential, and not terribly complicated, part of the digital camera world—just the way slides and negatives, which store images in different ways, are essential in the world of regular photography.

There are a lot of different digital file formats out there. That's partly because, for many years, every company that made something even vaguely visual for computers invented its own file format in order to display it. It's also because some kinds of images and graphics are better suited to certain kinds of file formats. Some file formats compact images into less space very efficiently—great for situations in which you don't have a lot of storage space. Other file formats are better at displaying fine detail, and they're used when space isn't as important as picture quality. Your camera will let you switch back and forth between formats (consult your manual for specifics, but it's usually something as simple as turning a dial or pressing a button). And yes, you can mix and match file formats on the same memory card.

Most digital cameras store images in a format known as **JPEG**. This file format is very efficient at storing photos in very small files without sacrificing much disk space. Another format you might see is called **TIFF**. Your camera might be able to store one or two TIFF images on a memory card instead of a few dozen JPEGs, for instance. As you might guess, TIFF is an extremely high-quality file format, but it guzzles storage space. Most of the time, you'll want to use JPEG—but TIFF is handy if you plan to print a particularly important image at 11 x 17 inches and need every bit of quality you can get.

COMMON FILE FORMATS

Once on your PC, you might want to convert an image into a different file format—to save space, to make it easier to trade with a friend, or to preserve image quality. Most image-editing programs can work with the most common file formats and will let you convert a picture into a different file format as easily as choosing File, Save As, and picking the format you like from the dialog box. Here are the most common choices:

JPEG The most popular format for storing and sharing photos, the JPEG format squeezes images into very small files. The downside is that you lose a small amount of image quality, and every time you re-save an image in JPEG it degrades a bit more.

TIFF This format takes a lot of disk space, but it preserves all image quality. If you plan to edit an image, you might want to first save it as a TIFF image—that way, you won't degrade its quality by saving it over and over.

GIF Along with JPEG, this is a popular format for posting images to the Web. Though bigger than JPEG, GIF files have other advantages on the Web, like the ability to be partially transparent.

BMP A popular format for adding an image to your Windows desktop as "wallpaper." Using this format, you can see a favorite picture every time you turn on your PC.

managing pictures

Deleting your images without trauma

As wonderful as your photographic skills may be, you won't want to keep all your pictures every single time you download them to your PC. And digital images are a lot easier to delete than film—there's no guilt about tossing perfectly good prints in the trash.

Deleting an image from your computer's hard drive—permanently—is as easy as pressing the Delete key on your keyboard. Just click on an image file you want to trash and press the key. Deleting is serious business, so Windows will warn you with a message box asking if you want to send the file to the Recycle Bin. Just click Yes and it'll be gone. (But not forever; to permanently delete you have to empty the Recycle Bin—see Now What Do I Do? page 92).

Of course, managing your files means more than just deleting images you don't like. Here are some other things you can do to put your digital image collection in order.

Move an image to another folder. This is a snap—just click on the image you want to move and continue to hold the left mouse button down. Then drag the icon to the folder you want to move it to and let go of the mouse. If you drag an image to a floppy or Zip disk, the image will be copied, not moved—Windows assumes you want to keep a copy for yourself in your PC.

Rename an image. If you want to change the name of an image to something more descriptive, just right-click on the icon and choose Rename from the menu that appears. Type the new name and press Enter.

ASK THE EXPERTS

Can I delete a bunch of images at once?

Yes, you can. It's this easy: just hold down the CTRL key on your keyboard and click on each file you want to delete. Don't let go of the CTRL key until you're done clicking—then press the Delete key to get rid of them all at once.

Can I create new folders on my computer for pictures?

Sure. Just open the folder into which you want to put a new folder, and right-click on a blank space where there aren't already any folders or files. Choose New from the menu that appears and click on it. You get the sub-option folder. Then type a new name where it says New Folder. Press Enter on the keyboard and you're all set.

How do I make a copy of an image in another folder—so I can edit it without messing up the original?

There are a few ways to do that, but the easiest is to right click on your image file and drag it—holding down the right mouse button—to a new folder. When you let go, Windows will ask you what you want to do. Choose Copy Here from the little menu.

erasing the memory card

Starting fresh with your camera

After you've copied a batch of pictures to your computer's hard drive, the last thing you need is a memory card in your camera full of those same old shots. What you really want is to erase that memory card and start fresh with blank memory so you can take all new pictures.

Depending upon whether your camera is connected to your PC or not, there are two ways to delete the images.

▪ If you can see your camera's contents like a folder of files on your computer's desktop, just select all the images (drag a box around them by holding down the left mouse button and dragging) and press the Delete key on your keyboard.

▪ If your camera isn't connected to the PC, you need to use the camera's menu system. (See pages 24–25.) This technique varies depending upon the kind of camera you have, so you might want to check your camera manual. In general, though, set your camera to Playback mode, press the menu button, and cycle through the options until you see a command to format or erase the memory card.

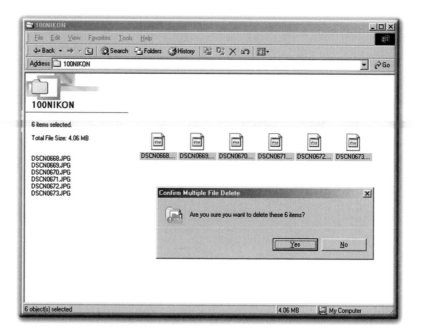

ASK THE EXPERTS

How many times can I reuse a memory card?

More times than you'll ever need to. Unless you actually damage it—like by dropping and stepping on it with a set of cleats—you can reuse a memory card hundreds of thousands of times. And that's more than most people can ever hope to use their camera.

If I forget to delete a memory card when I'm at my computer, can I do it later when I'm out with the camera?

Yes, you can. But don't forget that erasing a memory card takes some battery power, and your battery life is always at a premium. So avoid doing anything that takes energy when you're out shooting pictures, or you might run out of batteries before you run out of film.

CARRY A SPARE

If you can afford it, it's a really good idea to carry an extra memory card with you in your camera bag. That way you can always switch over to a new "roll of film" if your main card fills up too quickly. What's the price range? Well, there's a big variation, from $100 for small cards to as much as $1000 for really high-capacity cards. Typically, people buy additional memory cards in the $100-$200 range. It may sound like a lot of money, but remember, you can reuse these cards for years.

storing old images

What to do when your hard drive fills up

Even small **JPEG images** (the file format your camera stores your pictures in) can fill up your computer's hard drive in no time. Your first impulse might be to start deleting old pictures to make room for new ones—the digital equivalent of spring cleaning—but there's really a better way.

Take your old pictures and **archive** or store them. You can store vast amounts of pictures on special storage disks—called Zip disks. To archive stuff on Zip disks, you need to purchase a Zip drive and disks. Zips can cost $70 to $150. Then you can clear out your hard drive, so you can start storing some new images.

You can also archive images on CDs. To create CDs, all you need is a PC with a CD-RW drive (not the same as the regular CD-ROM drive that comes with most computers, this one can not only read disks, but can copy data onto them), and some blank CDs. You can purchase a CD-RW drive and CDs at a computer store. The price ranges from $150 to $200. Additional CD-R (recordable) disks cost less than a dollar.

zip drive

FIRST PERSON DISASTER STORY

Lost It All

As a fanatical photography buff, I took hundreds, maybe even thousands, of pictures with my digital camera last year. I had quite a load of images on my computer when disaster struck—one day I turned on my PC and all I heard was a loud, repeating clicking sound. Technicians told me, in gruesome detail, that the hard drive had crashed. I lost all my data in a flash, including a few gigabytes of irreplaceable digital images. Based on that experience, I highly recommend that you back up all your important pictures to CD or Zip disk.

Beverly F., Point Pleasant, Utah

HAT IF

Your computer doesn't have a CD-RW drive?

You can ask your local computer shop to add one for you. Or you can buy an external CD-RW drive and install it yourself.

You want to lend pictures on CD to a friend?

There are two kinds of CDs: CD-R and CD-RW. While **CD-RW** (read-write) disks have one major advantage (you can copy and erase data on them over and over, ad infinitum), they're much more expensive than **CD-R** (recordable) discs and are not always readable in other people's CD-ROM drives. CD-R disks, on the other hand, are a better choice. Although they are write-once disks, so you can't change data on them, they work on everyone else's CD-ROM drives and are much cheaper. These are the same disks you want to buy for copying music, since they work in portable CD players.

now what do I do?

Answers to common questions

After I copy images to my computer, can I resize them?

Yes, you can. You'll learn how to do that in Chapter 7. Remember, though, that while you can make a picture smaller, it's difficult to make it bigger. That's because the computer can't add detail to a picture that wasn't there to begin with, and it can end up being a blurry mess.

After I store pictures on a memory card, can I use that same memory card in other devices, like a music player?

Certainly. You can use the memory card in any device that it fits into, but remember to erase all the data off the card before you do so. A music player can't understand image files, for instance, so that will just be wasted space your music player won't be able to use.

I'm nervous about damaging my memory cards.

That's not really a problem. But to put the matter to rest once and for all, Compact Flash cards, for instance, are designed to be dropped from over ten feet onto a hard floor without damage. They can also be used for over 100 years without wearing out. But no, they're not edible.

What size hard drive should I look for if I'm buying a new computer and plan to do a lot of photography?

The one with the most memory. That's because high-resolution (maximum clarity) images and pictures saved in TIFF format take up a lot of memory, but even low-resolution JPEGs (another file format) can eat up lots of storage space in short order. Considering the price of hard drives these days, 20GB (GB stands for a gigabyte, or a thousand million bytes of information) should be the smallest you consider.

I've deleted a ton of pictures but I'm not getting any hard drive space back. Why not?

Well, Windows doesn't really delete anything when you press the delete key. Instead, the images go into the Recycle Bin, which you can see on the Windows desktop. When you're sure you want to delete them permanently, right-click once on the Recycle Bin and choose Empty Recycle Bin from the menu.

How do I get something back from the Recycle Bin?

Double-click with the left button on the Recycle Bin. A window should appear that shows you all the files in the Bin. Locate the file you want to keep, right click on it, and choose Restore. The file will reappear in the folder where you originally stored it.

If I copy pictures to a CD, can other people use it in their computer to see my pictures?

Absolutely—that's one of the best parts of having a CD-RW drive in your computer. Copy images to a CD-R disk (not a CD-RW) and anyone with a PC should have no trouble seeing your pictures.

What are Photo CDs and Picture CDs?

They are a special kind of CD, developed by Kodak, that you can get made when you develop 35-mm film. Most photo developers can copy your pictures onto a Photo CD or a Picture CD when you drop off your film. It's a way to hedge your bets and do both film and digital at the same time. You can e-mail, print, and share pictures on those disks just like ordinary digital images. Just load them into your CD-ROM, as you would a computer game.

OW WHERE DO I GO?!

CONTACTS

Lexar Media memory card resource:
www.digitalfilm.com

Sandisk memory card resource:
www.sandisk.com

Editing your pictures on the PC

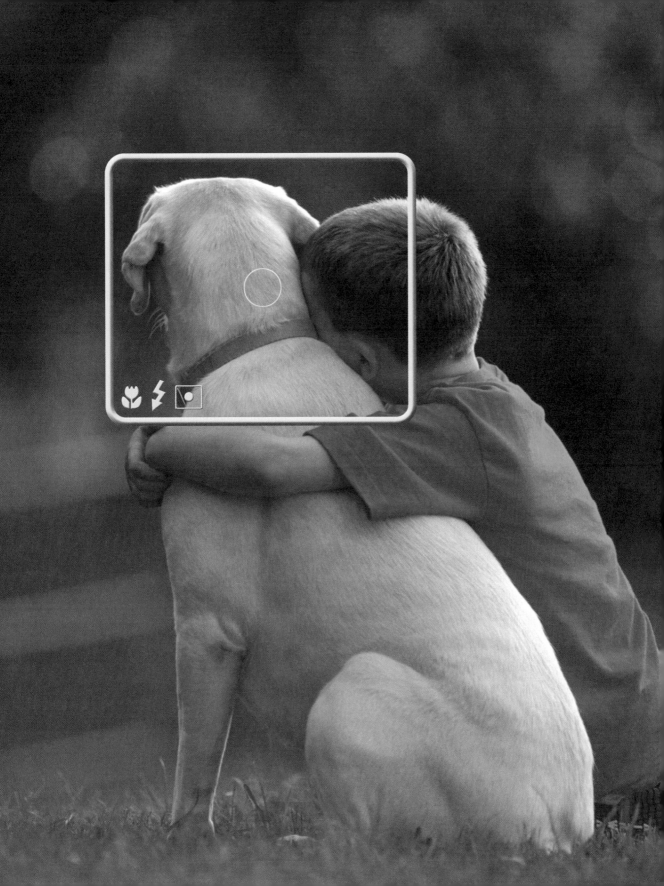

image-editing software

Choosing a program to tweak your photos

Have you ever been inside a darkroom? If so, you know it's not pleasant. It's dark and cramped and stinky, and you have to work with all kinds of nasty chemicals that probably aren't particularly good for you. And learning how to improve on your photos in a dark-room takes a whole lot of practice and skill. But now, if you want to brighten or darken a photo, or crop it, or make any of a thousand other little tweaks to it, there's an easier way—your computer.

Not only can you edit your digital images on the PC without any toxic chemicals, but image editors are—believe it or not—pretty easy to use. Most have **wizards,** or built-in program helpers, that auto-mate a lot of common things you'd want to do to your picture, and it really only takes a few hours to master everything else.

Your computer or your camera may even have come with an image-editing program. And if you like it, that's fine. But remember this: Just because it came with your camera, it doesn't mean you have to like it. Or use it. You can go to your local computer store and pur-chase any image-editing program on the shelf, and they'll all work just fine with your digital images. (But as with any soft-ware you buy, don't forget to check the system requirements on the box to make sure it works with your computer.)

Jasc Paint Shop Pro 7

Safari adventure

HAT'S OUT THERE

There is a lot of image-editing software on the market, and for the most part, any of them will get the job done. Here are some of the best programs to keep an eye out for.

Adobe Photoshop The choice of graphics professionals, Photoshop is an outstanding image editor, but it's a large, full-featured program that can be intimidating. If you take your image-editing work very seriously, this is the program to get. You can find the LE, or "lite" version of the program, with some features missing, in many digital camera kits.

Paint Shop Pro This program is a great alternative to Photoshop. Packed with 80 percent of Photoshop's features for a fraction of the price, it's also easier to learn to use. Better yet, you can download and try it out free from **www.jasc.com**.

Image Expert 2000 Really a cross between an image-editing and an image-cataloging program, this handy little program is very user-friendly thanks to a slew of wizards (built-in helpers) that improve your photo automatically. Some people use this program to instantly clean up, brighten, and sharpen their pictures, and then use another program, like Paint Shop Pro, for more advanced work.

inside an image editor

A road map to the features you need

Although image editors may behave and perform differently, they actually have a lot in common. All image editors have cropping tools that allow you to perform surgery on whatever part of the picture you select. Image editors all include a color palette so you can choose different shades for painting and editing. They all have text tools for adding words to your picture. Here's a sample from Adobe Photoshop.

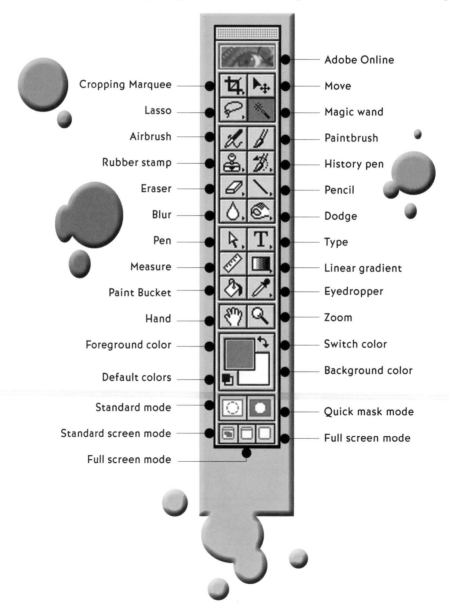

Adobe Online

Cropping Marquee — Move

Lasso — Magic wand

Airbrush — Paintbrush

Rubber stamp — History pen

Eraser — Pencil

Blur — Dodge

Pen — Type

Measure — Linear gradient

Paint Bucket — Eyedropper

Hand — Zoom

Foreground color — Switch color

Default colors — Background color

Standard mode — Quick mask mode

Standard screen mode — Full screen mode

Full screen mode

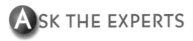

ASK THE EXPERTS

I am not particularly artistic. I just want to take pictures and print them. Do I need to use an image-editing program?

You certainly don't have to use an image editor just to take pictures and print or distribute them. But you can learn editing skills quickly that will dramatically improve your pictures after they're stored on your PC—so it's worth your while to try out one of these programs.

I'm afraid that if I edit a picture, I won't like what I've done and it'll be ruined.

Don't worry. When you open a picture in an image-editing program, you can do anything you like—including painting a little mustache on your mom's face—and the original image is unchanged until the moment you press the Save button. In fact, you can choose Save As from the program's File menu and save the changed image with a different name. That way you have the original picture and the changed one stored separately. Of course, don't forget about the Undo feature—before you press Save, anything you do can be "undone" by pressing Undo, which will make the picture revert to the way it looked before.

Should I use the automatic correction features in my image editor or try to do it by hand?

The automatic tools, like auto color correction, for instance, are nifty for quickly improving the original image. But you may not always like the automatic results. Your best bet? Try out the automatic feature, and if you don't like it, press the Undo button and try it without the automatic features.

rotate a sideways shot

Don't twist your neck to see your pictures

Believe it or not, the single most common reason people edit their pictures on a PC is to turn them sideways. You see, frequently folks turn the camera to take a vertical shot, and then the picture looks like it's lying on its side instead of standing up straight when you finally see it on the computer.

There's an easy solution to this problem—use the Rotate tool in your image-editing program, which lets you rotate pictures in 90-degree increments to the left or the right. Just figure out which way you need to turn your photo and choose the appropriate command.

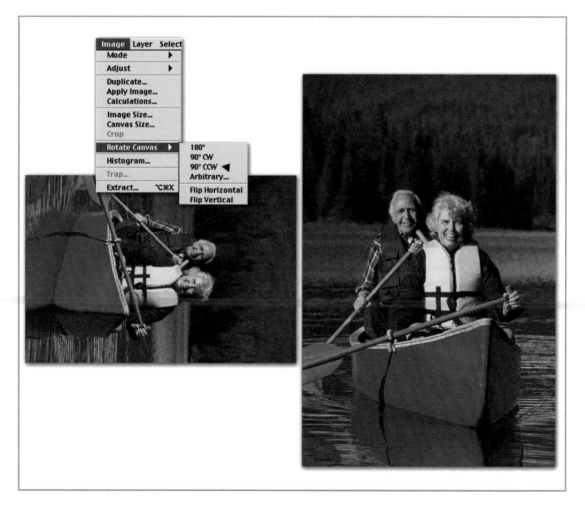

STEP BY STEP: ROTATING A SIDEWAYS PICTURE

1. Display your photo in an image-editing program, such as Paint Shop Pro or Photoshop LE.

2. Find the Rotate command. If you're using Paint Shop Pro, for instance, choose Image, then choose Rotate from the menu.

3. Choose both the direction of rotation and the number of degrees—say, in this case, you want to rotate 90 degrees to the left. Click OK.

4. The image should rotate. If you accidentally turned it in the wrong direction, choose Edit, then choose Undo from the menu and try again.

5. If you're satisfied with the way the picture looks now, save your work. Click the Save button to replace the original sideways image with this new and improved version. Otherwise, choose File, then Save As and save the picture with a different name. This way you get to keep both your new edited version and the original photo.

cropping pictures

Cut away the parts you don't like

Bet you didn't notice that tourist wandering around in the background of your picture when you took the shot. But that's okay—cropping is your secret weapon to improve your composition long after you take the picture.

Cropping—cutting away a bit of the picture to give you a new composition or to eliminate an unwanted element in the picture—has always been used by professionals, but few ordinary folks crop their own shots. Why? When you are using film, it's hard to crop your own photos. You either need to have your own darkroom or you have to take your prints to a local photo shop to get your images cropped and reprinted just the way you like.

On the computer, though, you can crop a photo and print a new, improved version literally in seconds. And the ease with which you can crop means you can feel free to take more pictures even if they're not composed perfectly—and make them better afterward.

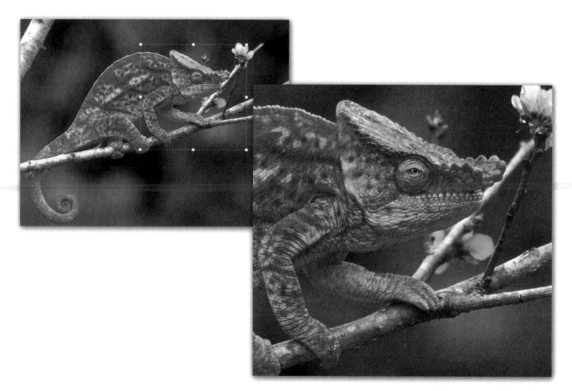

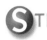STEP BY STEP: CROPPING

1. Display the picture that you'd like to crop in your favorite image-editing program.

2. Choose the Rectangular Selection tool, then click and drag the tool in the picture to create a box around the part of the image you want to *keep*. Everything outside the box will be discarded.

3. If you don't like the new composition and want to try again, click outside your crop box, then draw a new one.

4. When the image is properly cropped, you need to copy the contents of the box to the computer's clipboard, which is a place you can temporarily store data for later use. Choose Edit, Copy from the menu, and your data will be stored.

5. Now paste the data into a new image window. In Paint Shop Pro, for instance, choose Edit, then Paste, then As New Image. You should see the cropped picture appear on-screen.

6. Save the new, improved picture by choosing File, then Save As, and give the image a name.

7. You can close or even delete the original image if you don't think you will need it any more.

EASIER CROPPING

If your image editor has a special Crop tool, you might want to use it instead of copying and pasting. Just create a box with the Crop tool, then click the control that crops the image. Instead of getting a second image, the original file will be cropped. Another advantage to a special crop tool: you can drag the sides of the crop box around or change its size to fine-tune your new picture.

straightening a crooked picture

Keeping your horizon level

There's nothing quite as annoying as a crooked picture. You know the kind—where the horizon goes all the way across the picture, but it's just a bit off kilter so it looks like it was taken on a listing cruise ship.

Anytime you have a long straight line in a picture, if it's not true—level across the shot or straight up and down—the whole picture looks bad. Luckily, a slightly crooked picture is easy to fix using a technique that's pretty similar to the way you can rotate a sideways photo (see page 100).

There are two steps to correcting a crooked shot. First you need to rotate the image in tiny increments until it looks level. Then, since the picture will itself be crooked, you'll need to crop it down until it looks right again.

STEP BY STEP: STRAIGHTENING A PICTURE

1. Display your photo in an image-editing program.

2. Find the Rotate command. If you're using Paint Shop Pro, for instance, choose Image, then choose Rotate from the menu.

3. You won't need to rotate the image much—typically, crooked shots need one or two degrees of rotation at the most, and often you need less than that. For really small corrections, you can enter less than a degree, such as .10. Choose both the direction of rotation and the number of degrees and click OK.

4. The image should rotate. If the result isn't perfect, choose Edit, then Undo from the menu and try again. Don't perform a rotation on top of a rotation, though, or the image might start to look a bit distorted. Always start from the original position and do the whole correction in a single rotation.

5. Now you should see that the edges of the picture are rotated, like a picture that slipped in a frame. Using one of the cropping techniques described on page 102, crop the image down slightly so that you can't see the crooked edges.

6. When you're happy with the result, choose File, then Save As, and save your new, much improved photo.

sharpen a blurry shot

Make almost any picture look better

You're thinking, wow, I can sharpen a blurry picture. Isn't technology great! Well, yes—you can sharpen a picture that's a bit blurry or "soft." But unless you have your own genie and a couple of wishes left, you can't sharpen a picture that's really blurred or out of focus. In other words, digital trickery can't add information to a picture that wasn't there when you pressed the shutter release. That's why you should strive to take sharp, in-focus pictures right from the get-go. But if your images need a little help, that's okay . . . here's how to fix them.

Almost all image editors come with a set of sharpening tools or filters that you can use on a photo to increase the apparent sharpness. What they really do is increase the **contrast** (in other words, the difference in degree between light and dark) in the image, which has the effect of making it look sharper. There are three kinds of filters.

Sharpening Use this basic tool if it's all your program has. It increases the contrast of all the **pixels** (color dots) in your image at once.

Edge Sharpening A better bet—this tool only increases contrast along edges in your picture, where a lack of sharpness is more obvious.

Unsharp Mask This one sounds scary, but it's the most powerful and most effective sharpening tool around. It's the one used by most professionals. This tool has options you can experiment with, but the defaults are almost always fine.

ASK THE EXPERTS

Can I use sharpening techniques on a really blurry picture?

You can try—but a picture that's obviously blurry, such as from camera shake—won't improve much, if at all, from sharpening filters.

I'd like to sharpen just my subject, but leave the background fuzzy. How do I do that?

You need to select the subject. Your image editor comes with a variety of selection tools for isolating specific parts of the picture. After you select a specific part of the picture, run the sharpen tool and it'll only affect the region you have selected. Alternately, you can select just the background of a photo and the blur filter. That'll make the background look out of focus compared to the subject.

What do the options that come with the Unsharp Mask tool or filter mean?

There are usually three options—strength, radius, and clipping. The **strength** is the intensity of the contrast effect. **Radius** determines how many pixels on either side of an edge will be affected by the command, and **clipping** refers to how much difference, or contrast, there needs to be between pixels (color dots) before the program considers them an edge.

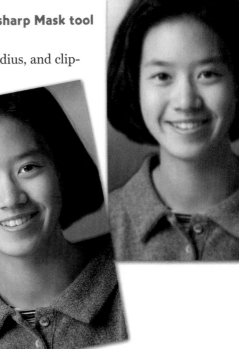

The near right photo has the Unsharp Mask Filter applied to it.

fixing brightness and colors

Get the bright and vivid colors you paid for!

Sometimes the light isn't quite right when you take the picture. Sometimes the camera's exposure is a bit off. Well, fear not, because you can use your image editor to tweak the colors and brightness of your pictures.

Most image editors have way more color controls than you could ever learn to use. But if you stick with a few of the most common ones, you can add some snap to your photos pretty easily. Most images can be improved with the **gamma control**, for instance. Gamma is like the brightness on a TV set—it lightens or darkens the image. But unlike plain old brightness, gamma affects the brightest and darkest

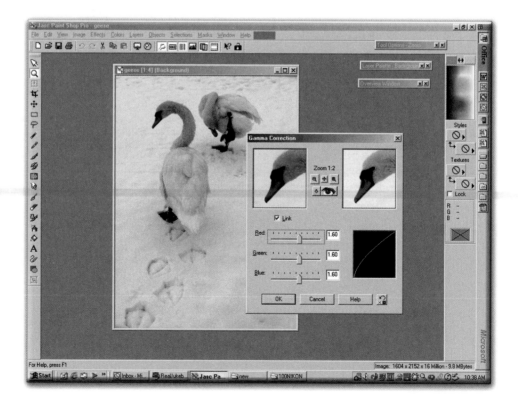

parts of an image less than the middle tones. Here's why: Suppose you're trying to brighten a picture that has some dark shadows in the background. The **brightness control** makes everything brighter, so it would turn the shadows from rich black to gray. Gamma, however, brightens the middle tones of the image without affecting the shadows—and that makes a better picture.

Of course, if your image-editing program has an automatic color and contrast control, try it out. You just might like the results, and letting the software do all the work is easier!

UNDERSTANDING YOUR HISTOGRAM

Probably because it looks kind of like the sort of graph you'd see in a high school math class, most folks are afraid to mess with the **histogram** feature of their image editor that shows you the color distribution in a picture. If your picture's histogram has a curve that doesn't quite reach the low or high end of the histogram, then you can use a simple technique to "stretch" the graph to deliver a wider range of hues in your picture. Why do this? Because it brightens or darkens an under- or overexposed photo.

Try it. Open a picture in your image editor and display the histogram. In Paint Shop Pro, for instance, choose Color, Histogram Functions, Histogram Adjustment.

You should see a slider at each end of the histogram. The low slider sets the black point in the image while the high slider sets the white point. If the curve trails off to zero and leaves a gap before the extremes of the graph, then no pixels (or at least very few) are using the shades at the low or high end of the color spectrum. The solution? Drag the sliders until they touch the point in the graph where the curve hits the bottom. You should see an immediate change in your picture.

remove red-eye

Your friends aren't evil, so why are their eyes red?

Everyone has a few. They're pictures of people with eyes so red they look like extras from a horror movie about people with laser beams that shoot out of their pupils. Even animals get red-eye, and by some accounts, that's even creepier.

Red-eye has a very natural explanation, though. In a dark environment, your pupils expand to take in as much light as possible. It's like the way a camera's aperture (see Chapter 3) opens in a dark room. But when you take someone's picture in the dark, the bright flash reflects off the retina and looks like a red glow. Red-eye doesn't occur in brighter conditions because the pupil is smaller, preventing the flash from reflecting off the eyes to the same degree.

If you've got red-eye in your picture, one solution is to turn on the **red-eye reduction mode** on your camera and try again. Red-eye reduction pre-flashes the camera before the picture is taken, which coaxes the pupil to close. If it's too late for that, you can paint the red part by hand in an image editor. Paint it black, brown, or blue to match the person's real eye color.

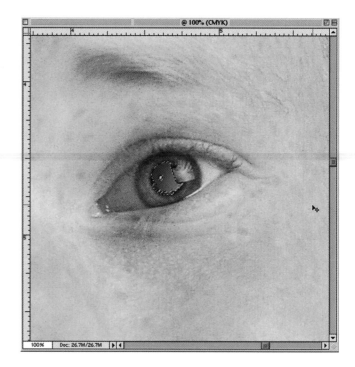

STEP BY STEP: PAINT OUT THE RED

1. In your favorite image editor, open a picture that has red-eye.

2. Use the zoom control to zoom in until one of the eyes fills most of the screen. You'll need a good view of the eyes to remove the red.

3. Select the Magic Wand tool. This is a clever selection tool that chooses all the nearby pixels of similar color. Suppose you click on someone's white shirt, for instance. The Magic Wand will select the entire shirt because all of the pixels in the shirt are roughly the same color.

4. Click in the red part of the eye. If the Magic Wand doesn't get the whole red section, hold down the Shift key and keep clicking around the eye until the entire "red donut" is selected.

5. When it's all selected, grab a paintbrush or airbrush tool and fill in the selected region with black or another dark color.

6. Slide the picture around so the other eye fills the screen and repeat the process.

7. When you're done painting the eyes, save your picture.

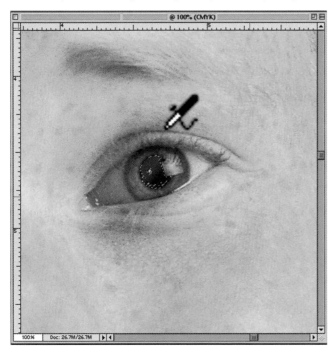

eliminate dust and scratches

Clean up those antique photos

It's heartbreaking to find scratches and tears in important family photos, especially if there are no longer negatives around that you can use to reprint them. Wedding photos, for instance, are typically one-of-a-kind pictures that can't be reprinted years down the road.

Equipped with a scanner, though, you can "repair" damaged photos electronically and print the result. With a good inkjet printer, it can be hard to tell the difference between the original and the reprint . . . except that the reprint won't be scarred.

The key to fixing old photos is a tool found in most image editors that usually goes by the name Clone. The **Clone tool** lets you paint one part of a picture using another part of the picture as the source. Suppose there's a tear that goes through the sky, for instance. Just paint over the tear with a nearby patch of sky, and the scratch is gone.

Of course, this technique doesn't work if the damage goes through a very complex part of the picture, but a lot of the time it can transform a photo from trash to treasure.

HONING YOUR STROKES

Often, the best way to cover damage using the Clone tool is by dabbing and making lots of short strokes. Larger, longer, more uniform strokes can make it easy to see that you have simply copied a large swatch from elsewhere in the picture. It certainly pays to experiment to get the best results.

STEP BY STEP: ERASING SCRATCHES

1. Scan the damaged picture and save it on your computer's hard drive. Then open the image in an image editor.

2. Inspect the damage. The easiest scratches to fix are ones that occur in fairly uniform backgrounds, as in grass or sky, or against a wall or a regular cloth pattern. Find a spot that you'd like to repair.

3. Click on the Clone tool.

4. Place the Clone tool near the damage in a similar region that will blend in if you copy it on top of the scratch or tear.

5. Move the mouse over the damaged part of the picture and start painting. Cover the damage with the cloned near-by colors and patterns.

6. When you're done, save your finished picture.

adding text to a picture

Make your own headlines

Now that you're becoming an expert photographer and image editor, why not add some text to your pictures? Equipped with almost any image editor, you can add captions or headlines to images that you e-mail or post to the Web, or even get fancy and turn pictures into greeting cards and other projects.

Image editors work a bit differently from the word processing program you're probably used to using. When you click on the Text tool and click in the picture to lay down your text, you don't actually type into the picture itself. Instead, a text entry dialog box appears. Type your message there—then select a text font (style of typeface), style (italic or bold), size (point size), and any other details you want to specify. Then click OK and the text appears in the image. You can select it and move it where you want it.

You'll generally have to make your text size quite large, depending upon the size of the image itself. A 12-point type size looks normal on a computer screen, but it's simply too small for a headline. It's a matter of personal taste, but most people will want to use 30- or 40-point size on a photograph. And remember: you might be able to fine-tune the position of the text when you first apply it to the picture, but after that it becomes a permanent part of the image and can't be moved around. If you're not happy with your results, you'll either have to click Undo, or close the image, reopen the original, and try again.

ASK THE EXPERTS

I love drop shadows around text. Can I get that effect in my pictures?

Sure. Drop shadows, in which there's a "shadow" layer of text under the main characters, are easy to produce. Just stamp the same message down twice. Start with black letters, then stamp it again with light-colored letters. Position the second set of letters slightly above and to the left of the black letters, and the result will look like text with shadow.

How do I make letters that are filled, not with color, but with parts of a picture—like a stencil?

You need a program that lets you create a "selection" of text, like Paint Shop Pro. Here's what you do: Open the text-entry dialog box by clicking on the Text tool and then clicking in the picture. Make sure the option to Create As Selection is picked. Then write your text and click OK. When the text appears, choose Edit, then Copy, from the menu, and then paste that selected text into your picture. That's it!

Why is my text so hard to read when I display my pictures on TV using my computer's video-out cable?

Video can be tricky. What you should remember is that thin fonts or typeface tend to disappear in video, so use the thickest characters you can get your hands on. Scroll through your computer's font options and go for fonts that look fat. Fonts that you usually type with—like Times New Roman—are awful for video work. Also, make the type bold.

save an image
in a different file format

**Because Uncle
Steve can't view
JPEGs**

There's a veritable alphabet soup of **file formats** (the ways information is stored) out there in computer land. There are four reasonably common file formats for photos (JPEG, TIFF, GIF and BMP—don't worry about what those letters stand for) and another hundred or so that are used on a much less frequent basis. And though you'll usually stick with JPEG, it's reassuring to know that you can switch among file formats as easily as changing socks.

Your image editor lets you save your pictures in any of a dozen or so image formats. You can see this for yourself. When you choose File, then Save As from the menu, you should see a Save As File Type menu list. Click the list and you will see lots and lots of options—JPEG, GIF, BMP, IFF, TIFF, and so on. So if Uncle Steve calls you up and says that he can't see the picture you just e-mailed because his Stone Age computer can't read a JPEG file, then all you need to do is save the picture in a format he can use, such as a BMP format, and send it again.

Depending upon which file format you choose, there may be options you can play around with. You can control how much JPEG compresses your picture (in other words, how much it squeezes the data into a smaller size), for instance, or how many colors the BMP file format (the one used for adding an image to your Windows desktop as "wallpaper") uses to save your picture. With BMP, you can specify 2-color, 16-color, 256-color, and so on. You can usually ignore these options and use the defaults, but they're handy to experiment with if you don't get the results you expect.

 ## ASK THE EXPERTS

What file format works best on the Internet?

You can use either GIF or JPEG on the Internet. JPEG is often the better bet, though, because it can make smaller files that load faster on Web pages. You can do some fancier things with the GIF format—like make the background of the image transparent or make it appear in stages so it seems as though it displays faster, but JPEG's smaller file size probably wins out.

What file format should I use to send an image to a friend who has a Mac?

These days, Macintosh computers can handle most file formats that PC users work with. But to be on the safe side, stick with the TIFF file format. It was originated on the Mac, and all Macs can read it just fine.

When I save an image in JPEG format, what compression factor should I use?

A low compression rate gives better quality but the data is less squeezed, so it takes up more space on your PC's hard drive. Conversely, a high compression rate makes a very small file, but the quality may be poor. You should use a reasonably high quality, low compression rate on any files you plan to open, edit, save, edit some more, then save again. That's because every time you save a JPEG file, it gets recompressed—and the quality will start to deteriorate rapidly.

now what do I do?

Answers to common questions

The colors look off in a picture—there's too much red. What can I do to correct the color?

You can use the Color Balance tool found in most image editors to tweak the colors in a photo. The controls should let you adjust the red, green, and blue content (the primary colors in computer land) of the picture with a trio of sliders. In general, the rule of thumb is to reduce the color there's too much of, but also to increase the other two primary colors by about half that amount. Be conservative and make your adjustments a little at a time.

What is automatic color correction? Does it work?

Many image editors have an automatic color correction mode. You can try it and see if you like it—often the results are uncannily good. You probably have to tell the program what kind of light the picture was taken in, though—such as daylight, fluorescent, or incandescent lighting.

When I use the zoom control to magnify my image, does that permanently enlarge it?

No, the magnifying glass or zoom tool is there in your image editor for you to better see small details in your picture. You have to resize or resample your picture to enlarge it. (You'll learn how to do this in Chapter 7.)

Sometimes I want to copy several things to the clipboard and paste them, one at a time, into a new photo. How do I put multiple things in the clipboard?

Well, you can't—Windows only lets you put one thing at a time in there. But don't let that stop you. Copy an item and paste it into a new, blank image (usually you click on the File, then the New menu item to get a blank image). Then store more items in the blank image. You can use it as your own enhanced clipboard.

How can I select the background in an image to blur it? It's easy to select a small part of the picture, like the subject, but selecting the entire background is really hard.

There's a simple solution to this problem. Select the easy part—like the subject. Then use the image editor's clever Invert Selection tool to select exactly the opposite! In Paint Shop Pro, you can find that command in the menu by choosing Selections, Invert.

Is there a way to select more than one part of a picture? Suppose I want to sharpen two people who are on opposite sides of a picture and aren't touching?

For this, you can use the Selection tool along with a key on the keyboard that lets you combine selections. Select the first region. Then press and hold the Shift key as you make your second selection. You can use this technique to select several elements in the photo, even if they don't touch.

How much memory does my computer need to edit digital images?

To speak like a total techie, you should have 128MB of RAM. (To translate, MB is megabytes, or a million bytes—bytes are the computer's storage units of information. RAM stands for Random Access Memory. Don't worry, you don't need to remember what all those letters mean, but it's good if you can get to the point where you can let the MBs and RAMs roll off your tongue.) If you work with really big images, or a lot of images at once, then 256MB is a good idea. Any local computer shop can install a 128MB memory card for you in about five minutes.

OW WHERE DO I GO?!

CONTACTS	PUBLICATIONS
Jasc Paint Shop Pro **www.jasc.com**	**Paint Shop Pro 7 for Dummies** By David C. Kay
Adobe Photoshop **www.adobe.com**	**Adobe Photoshop 6.0 for** **Photographers** By Martin Evening
Image Expert 2000 **www.sierraimaging.com**	**I'm Turning on my PC, Now What?!** By Matthew James

CHAPTER 6

Special editing effects

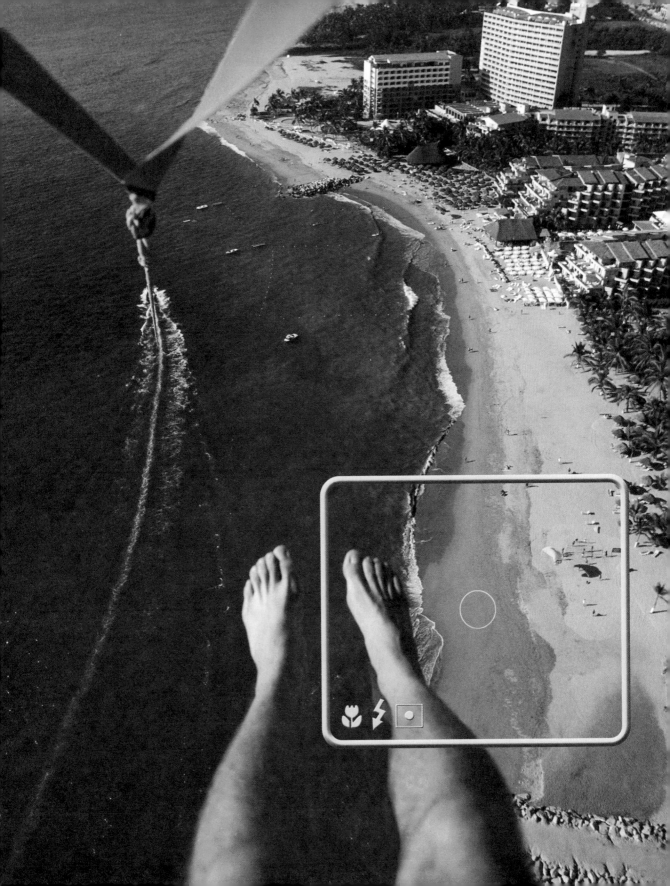

look like van Gogh

Adding painterly effects

Did you ever stare at paintings in a museum and wish you could create art like that? Well, now you can—if you don't mind cheating a bit. Many image editors work with a variety of plug-in **filters**, which are essentially little programs that modify your photograph in a specific way. There are filters that blur your picture, swirl it, pixelize it (which makes it look chunky, as if there were fewer pixels in the image), and create an untold number of other effects. And they're called plug-ins because while many come standard with your imaging editing software, you can buy them individually too. Although they were first designed to work with Adobe Photoshop, these filters come in a standard format that's compatible with a lot of image editors.

So, armed with a few plug-ins, you can transform your photographs into works of art. The best part of using filters is that there's no right or wrong result. Just apply a filter and see if you like what you get. If you don't, undo it and try a different effect. You can even combine effects—first run one filter on your picture, then run another on top. It's fun, and you just might get some very cool results.

Cross hatch brush stroke filter

WHAT'S OUT THERE

Perspective effect

Watercolor filter

There are hundreds of plug-in filters out there. Many come with your image editor, while you can purchase others. To find them, look in the menus of your image editor and keep an eye out for words like Filters or Effects. Here are a few filters and effects you can try out.

erase the tourist

Airbrush your troubles away

It's annoying. You take a beautiful picture of some breathtaking vista and then check your LCD for what you took, and you get a rude surprise: some guy you hadn't noticed is standing in the middle of the scene. And it's too late to go back and reshoot it.

Using computers, professionals can airbrush such eyesores away, and now you can too. Click on the Clone tool, a feature that lets you paint one part of a picture with pixels copied from another part of the picture. You can literally make many of the glitches in your photos disappear.

The Clone tool works well when you're trying to cover objects that are positioned over fairly uniform backgrounds. For example, it's easy to use nearby patches of sky to cover a telephone pole or an airplane. The Clone tool is trickier to use when you are erasing a large object from a very complicated part of the picture, because it's harder to make the item disappear convincingly. Nonetheless, it's a powerful tool—so go ahead and experiment! (For more ways to use the Clone tool, see pages 112–113.)

Use the clone tool to erase the boy in the distance.

STEP BY STEP: AIRBRUSHING A TELEPHONE POLE

1. Display your photo in an image-editing program.

2. Click on the Clone brush (or tool).

3. Locate an element in the picture that you'd like to erase. At first, until you get the hang of it, stick to small objects that appear on a uniform background.

4. Place the Clone brush near the object in a similar region that you can copy. Activate the Clone (in a program like Paint Shop Pro, just click with the right mouse button), and it will copy that part of the picture.

5. Move the mouse over the damaged part of the picture and start painting with short dabs. That makes it harder for a pattern to develop as you paint over the object. (Just like touching up your living room wall, you want the color to blend in.) Cover the object completely with the cloned pixels.

6. When you're done, save your finished picture.

stitch a panorama

Combine photos into a wide, eye-catching vista

If you want to capture the rugged beauty of the Grand Canyon, you probably need to do it in about four or five different pictures, because you just can't fit it all into a single frame. But what if you could combine all those individual shots into a really wide panoramic photo?

That's the idea behind **panorama software**. Back in Chapter 2, you learned how to take all those individual photos. Now it's time to stitch them together. And don't worry, you're not using a needle and thread. **Stitching** is the term used to refer to the automatic process your computer uses to combine all those pictures into a single image.

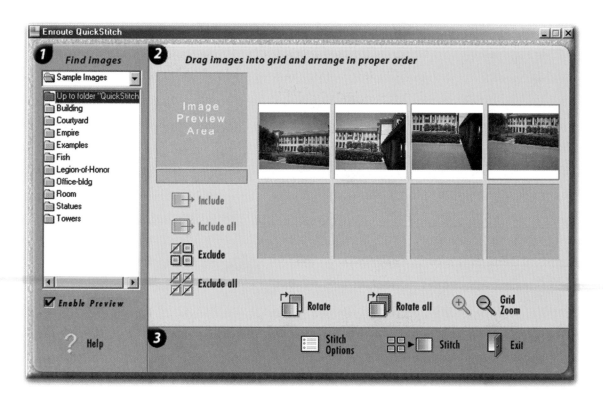

To get going, you'll need panorama software like MGI's PhotoVista, ArcSoft Panorama Maker 2000, or PanaVue ImageAssembler. All these programs work in more or less the same way—you just drag your shots into an on-screen grid so they're arranged in the right order. Then let the program work its magic. It finds the points where the pictures overlap and generates a finished shot in which the seams are hard or impossible to see. Some software can even create panoramas in **QuickTime VR format**. That's a special series of images that you can navigate among with your mouse. It makes you feel as though you're really there, because you can look up, down, and behind you just by dragging the mouse.

ASK THE EXPERTS

I tried taking a panorama, but it came out with ugly bands of light and dark. Why? What can I do about it?

It sounds as if you took so many individual pictures that the exposure changed dramatically from one end of the panorama to the other. You can usually see this best in the sky—one side of the picture may have a blue sky, while in the other side of the picture it'll be washed out due to the sun. There are two solutions—you can capture a series of photos that all face away from the sun, or you can use digital trickery to replace the washed-out part of the sky in an image editing program before you start stitching.

QuickTime VR sounds like fun, but what can you do with it? If you have to click around inside it, it doesn't sound like something you'd want to print.

The most popular place to put QuickTime VR files is on the Web. You can easily upload a few QuickTime VR images of your recent vacation, for instance, and let friends and family wander from place to place in Paris, the Grand Canyon, or anywhere else you've been. Real estate agents also use this format to let you wander through homes without ever leaving your living room, and it's popular on hotel Web sites, too.

STITCHING FOR PRINTING

Sometimes people take a bunch of pictures and stitch them, not to create a panorama but to generate a very very high-resolution image for large-format printing. If you take a picture of a car with a three-megapixel camera, for instance, the image will be three megapixels in size. But take a series of overlapping shots of the car and stitch them together, and you can have a ten- or twenty-megapixel image, suitable for printing at poster size!

decolorize your background

Add drama to your pictures with composite color shots

Have you ever seen a photo or a video sequence in which everything was black and white except for a single element? That kind of shot is very dramatic, and the human eye is drawn like a magnet to the color element in a sea of grayscale. Those shots sell lots of stuff on television commercials, and now you can do it yourself.

There are a number of elaborate steps involved in making your own composite color shot, but in reality it's pretty easy to do. And though it takes two cameras to get that kind of shot on television, with a digital camera you can do it with a single picture—and you don't even have to plan ahead when you take your photographs.

Here's the basic idea. You start with one picture and make a copy of it. Then you convert one image to black and white, and leave the other in color. You layer the color copy over the black and white. Then, from the color copy, select the part of the picture that you want to appear in color. Delete from your color copy everything that's not selected. You're left with a color element on top of a grayscale image.

STEP BY STEP: MAKING A COMPOSITE IMAGE

1. Some of the steps are a bit program-specific, so let's assume that you're going to use Paint Shop Pro. You can do this in other programs, but the specific menu commands will be a bit different. Load your image into Paint Shop Pro and make a copy by choosing Edit, Copy. This is your color copy.

2. Turn the original image into a grayscale picture by choosing Colors, Grayscale. Next select Colors, Increase Color Depth, then 16 Million Colors. Now it's a black-and-white image, but the program is leaving "room" for all 16 million colors (yup, that's photorealistic—the human eye actually sees that many colors).

3. Choose Edit, then Paste, then As New Layer. This takes the color copy of the picture from the clipboard and layers it on top of the black-and-white picture. If you need to, move the color image so that the two images overlap perfectly.

4. Now, on the color copy, use a selection tool to trace the subject that you want to keep in color. You can use the Magic Wand or any other selection tool that's convenient.

5. When you're done selecting, choose Selections, then Invert from the menu. That changes your selection so that everything except the color is now selected. It only affects the selected layer, so it won't change the black-and-white copy underneath.

6. Choose Edit, then Cut from the menu. The unselected region should disappear, leaving you with a color subject on a grayscale background.

combine your picture with a celebrity

Shake hands with Elvis, Nixon, Ringo, or anyone else

Forrest Gump got to meet JFK, and now you can too! Sure, it takes a little artistic skill, but the technique isn't all that difficult. Armed with an appropriate celebrity photo, you can paste yourself into the picture and tell your friends about how you performed a duet with Frank Sinatra.

The basic idea for creating trick celebrity shots isn't terribly different from making a composite color photo. (See page 128–129.) Here are the basic steps.

1. Find a suitable photo of a celebrity and scan it into your scanner. (See page 188–189.)

2. Find a photo of the person (yourself or whoever) that you want to insert into your celebrity picture, and crop it so your subject is about the same size as the celebrity.

3. Using a selection tool like the Magic Wand, select the person but avoid including any of the background.

4. Copy the person to the clipboard (choose Edit, then Copy) and then paste the subject into the celebrity picture.

5. Position the subject and save the result.

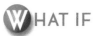HAT IF

The two people look quite different and don't look as though they belong in the same picture. How can you make it look more authentic?

Inspect the celebrity picture for details like sharpness and grain. You can run the blur or sharpen filter on the other person (see Chapter 5), or even add speckles of **noise** (it looks like static or dots, just as on a TV) to make the two look more similar.

What if the selection process isn't quite right and the outline around the subject looks a little too sharp to be believable?

If your cutout looks like just that—a cardboard cutout—you can use the feather feature in the image editor to knock some of the sharpness off the edge of the subject.

What if you don't own the celebrity picture? Can you use it?

That depends. If you are editing the picture for personal use and will never exhibit or sell it, it's perfectly okay to mess around with a photograph.

animate your images

Make those pictures dance!

Armed with your digital camera, you can take still images and be perfectly content. Or you might turn on your camera's MPEG movie mode and take short films (though not all cameras have that feature). One other, oft-neglected, option: take a bunch of still images and animate them.

Animating still images is fun and sometimes quite useful. If your child is doing a school report on flowers, for instance, what could be better than a short movie that shows how a flower opens in the early morning hours as the sun comes up? You can take a series of pictures at 15-minute intervals by hand, or set your camera to take time-lapse photos automatically (if it has such a feature built in).

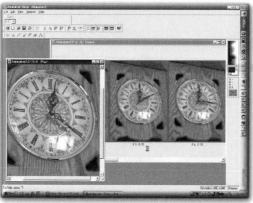

When you've got a slew of pictures that you want to combine into a movie, you need software that can animate them for you. One of the most common programs for doing this is Jasc Animation Shop. The process is pretty easy: open a new animation file, then select the pictures that you want to insert as frames in your animation, and you're done! There's even an animation wizard, or helper, to guide you through the process.

Completed animations can be e-mailed or uploaded to a Web site.

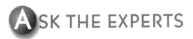SK THE EXPERTS

What size should my animation be?

Don't make it too big. Even if your original images are 640 x 480 pixels, for instance, the animation itself should be more like 240 x 120 so the movie will play well on all computers. You can specify the size of your movie when you start the animation wizard.

What format will my animation be? What computers can view it?

Most animation software saves your little movies in Animated GIF format. Any program that can display a GIF file can view your animation, so that includes most Web browsers on the PC and Macintosh.

How many frames should my animation have?

To look convincing, your movie should have between 10 and 25 frames each second; you can use the same image for six frames (or **cells** as they are called in the animation world). You can also adjust the frame rate within the animation program. Don't make the animation images too large because some computers won't be able to display large animation frames as fast as you'd like them to appear.

now what do I do?

Answers to common questions

Are there any free image editors out there?

Sort of. Your camera may have come with an image editor, and you can certainly use that one. In addition, many image editors can be downloaded from the Internet as **shareware**, which means you can try them out free for a while, before deciding if you want to actually buy them. Shareware versions of software are often limited—you don't have access to all the features or they stop working after a while—or are older versions of the program. Paint Shop Pro is one example of a shareware image editor.

I'm really intrigued by the possibilities of editing and manipulating photos digitally. Where can I read about other techniques and projects I can tackle?

Magazines are your best bet. Many monthly digital camera publications include lessons on how to work with image-editing software (see Now Where Do I Go?! on the next page).

Where can I find new plug-in filters for my image editor?

Some are available in stores in the same aisle where you'd find image-editing software. You can also search the Web for plug-ins and look on the Web site of your image editor—like **www.adobe.com** and **jasc.com**.

If I'm using a paintbrush to edit a picture, how do I erase a bad brush-stroke? The Eraser tool doesn't seem to work properly.

Just use the Undo command, usually found at Edit, then click Undo. That will remove the last thing you did and restore the picture to the way it looked before you made your boo-boo. The Eraser tool in many image editors is poorly named. What it actually does is let you paint with the program's currently selected background color.

I scanned an old picture into my PC and it has specks all over it. Is there any way to eliminate them digitally? I keep trying to erase things from my pictures using the Clone tool, but too much gets erased every time I click with the brush. What am I doing wrong?

The problem is that your Clone tool's brush size is too large, so you're working with a fist-sized area when what you need is a pinkie-sized region. Look in the tool's properties or controls for a brush size and reduce it.

There's an optimum middle ground. Too small and the pattern you copy will be too distinct to be believable. Too large, though, and you'll damage parts of the picture you didn't want to mess with.

How can I tell what file format my picture is currently stored in?

Every file format has its own unique three-letter file extension, like .jpg, .tif, or .pcx. Find the image on your computer's hard drive and right-click on it. Choose Properties from the menu and the Properties dialog box will show you the complete file name, including that three-letter extension that comes at the end.

My image editor has an option called watermark. What's that?

It lets you embed your personal information in the picture in a way that can be read by other watermarking software. Like a copyright, it's usually used to protect pictures from being stolen on the Internet or used without your permission. Watermarks aren't visible to the naked eye, but they can be seen with the right software.

OW WHERE DO I GO?!

CONTACTS

ArcSoft
www.arcsoft.com

MGI
www.mgisoft.com

Jasc
www.jasc.com

PanVue
www.panavue.com

Digital Camera
www.photopoint.com/dcm
530-676-7878

eDigitalPhoto
www.edigitalphoto.com
800-677-5212

CHAPTER 7

Displaying your pictures

sizing your pictures

The right size for the right job

At a dinner party, there are different plates for different parts of the meal. The salad plate and the entree plate are designed to serve different amounts of food, for instance, so they're a different size.

Digital pictures are a lot like that. You can't generally eat off them, but you can (and should) customize the size of your pictures to suit whatever job you have in mind for them. For example, Web pictures are typically smaller than pictures you plan to print, because if you make them too big, they'll be larger than the computer screen and people will have to scroll around to see the whole image. And the picture will take a long time to download too.

Any image-editing program is able to help you resize your images. In Paint Shop Pro, for instance, you can find the Resize tool in the Image menu. Just specify the number of pixels (tiny dots that form the image) that you'd like the image shrunk down to and save the completed image with a different file name. You can save the original file if you think you'll need the high-resolution version later (i.e., the one with more pixels, thus greater clarity in a larger size), or just delete it if all you'll ever need is the shrunken version.

ASK THE EXPERTS

What size should I use if I want to post pictures to a Web site?

Consider 640 x 480 to be the largest size you should use on the Web. In fact, you might want to set the longest dimension to be about 500 pixels. (The longest dimension will vary depending on whether the picture's orientation is landscape or portrait. In landscape orientation, the horizontal length will be the longest and that should be 500; for portrait, the height will be the longest, so set that to 500.) Your image-editing program will set the other dimension automatically. Why do all this? Because a smaller image will make the image display faster, and it's guaranteed to fit on the screen completely.

If I shrink an image, can I later enlarge it back to the size it originally was?

No, that's not a good idea. Once you resize a picture to a smaller size, you lose information that can't be restored. You literally lose some pixels, the tiny dots that determine the clarity of the image. So trying to enlarge an image back to its original size will simply make it blocky and ugly. If you think you'll need the image in a larger size—such as for printing—keep the original full-size image around with a different name.

AUTOMATED RESIZING

If you have a lot of pictures that you need to resize, it can get a bit annoying to do them all by hand. Imagine, for instance, that you took 100 pictures on vacation and you want to post them all to a Web site. That's a lot of resizing. Instead, try a program like Jasc Image Robot. This program lets you load a lot of images and perform the same operation—like resize and save—to all images, automatically. While you're eating lunch, Image Robot is converting your pictures for you.

Original size

Reduced size

Reduced size enlarged back to its original size

display on the desktop

Wallpaper your computer

So, every day you turn on your computer and stare at the same boring desktop screen. If you've never fiddled with the desktop, it may still have the logo of the company you bought the PC from. Or it might be plain green or blue. Whatever your desktop looks like, it's time to **wallpaper** (or cover) it with some of your favorite pictures.

It's easy to cover the Windows desktop screen with a picture. Any picture will work. Start by figuring out—if you don't already know—what the resolution (number of pixels) of your Windows desktop actually is (see next page for instructions). Then you can resize your image to match. When you apply an image as wallpaper, you even have a choice about how it appears. The image can be centered in on the screen (you'll see a border around the image if it doesn't completely fill the display), stretched to fit, or tiled, in which case it'll look like real wallpaper that repeats all over the screen.

You can change your wallpaper as often as you like. This Windows feature has little in the way of practical applications, but it's fun to see your favorite pictures on the Windows desktop every time you use your computer.

Centered on the screen

Stretched to fit

Tiled for wallpaper effect

STEP BY STEP: ADDING WINDOWS WALLPAPER

1. Start by determining the size of your Windows screen. Right-click on the desktop, making sure not to click on an icon or any other screen element. Click on bare desktop space. Then click Properties from the menu.

2. Click the Settings tab of the Display Properties dialog box. Look in the Screen Area section of the display—in the lower right—and write down the resolution. It will probably be either 640x480, 1024x768, or 1280x1024. Click Cancel to close the box.

3. Find the picture that you'd like to use as your wallpaper image and load it into an image editor. Using the Resize tool discussed earlier in this chapter, resize the image so that it's no bigger than the size of the Windows desktop. Save the file as a BMP image type (see page 85) because this is the file format for wallpaper.

4. Now it's time to wallpaper your desktop. Once again, right click on a bare spot of desktop and click on Properties from the menu.

5. On the Background tab of the Display Properties dialog box, look at the bottom section called Wallpaper. Click on the Browse button.

6. Find your image using the Open File dialog box. When you locate the image, click on it and then click the Open button to select it.

7. You should see the image appear in the little preview window. You can modify it using the Display box by choosing Center, Tile, or Stretch. Experiment to see which you like best.

8. Click OK to save your changes and actually apply your picture to the Windows desktop.

e-mail pictures

Sending
pictures
as attachments

Taking pictures is one thing; actually sharing them is something else entirely. This is one area where digital photography has a big advantage over 35-mm prints. Instead of letting your pictures collect dust in a shoebox somewhere, you can e-mail them to friends and family wherever they may be around the world. And since you've always got the original, you're not actually giving anything away!

E-mail is perhaps the most common way for people to share digital pictures. Why? Everyone has e-mail—at least everyone with a computer and an Internet connection—and it's easy. There's no messing with extra software, image viewers, or Web site addresses. Your friend just opens the message and double-clicks on the attached picture. The rest is automatic. You can exchange pictures no matter what kind of computer, e-mail program, or Internet access you have.

Digital images are stored in mail messages as attachments. An **attachment** is a file—it could be a spreadsheet, picture, or even a program—that you attach to your e-mail message. There are several ways to attach a picture to your e-mail message. After writing the e-mail the same way you usually would, you can drag and drop the picture file from the folder it is stored in into the message and let go. You should see it appear as an attachment at the bottom of the message window. Or you can click on the attachment icon in your mail program—it usually looks like a paperclip—to attach the image instead. Or you can go up to the Menu bar and find a button that says Insert or Attach, then follow the prompts to locate the picture file you want to attach. Click OK and there it should be in your e-mail message field.

To open a picture file attachment, just double click on the icon, here it's named Jasmine.jpeg.

ASK THE EXPERTS

Sometimes I'll have trouble sending pictures in e-mail—it either takes a long time or gets rejected by the mail server. What's going on?

You're trying to send pictures that are too big. Never try to e-mail megapixel images without resizing them first. The smallest readable size you can use is 200 pixels. If you want to attach several pictures, you might have to send more than one e-mail if the pictures are large.

If I send an image attached to an e-mail message, how does the recipient see the picture?

The easiest way is to simply double-click on the attachment and it will open, revealing the picture. The recipient can also save the attachment on the hard drive and then use an image editor or image viewer to display the picture.

How does someone know my picture isn't a virus? I heard that you shouldn't open attachments you get in e-mail because of the danger of viruses.

The first rule of thumb is never to open an attachment e-mailed by a stranger. The next rule is to check the last three letters in the attachment's file name. Images always end with .jpg, .pcx, .bmp, .gif—for example, myhouse.jpg. Those are safe to open. If the image file ends in .exe or .vbs, it could be a virus—discard it without opening it. Sometimes virus makers will disguise a virus by putting the letters .jpg in the file name, but even a file called openme.jpg.vbs is still a virus. Scrutinize those last three letters before you open an attachment.

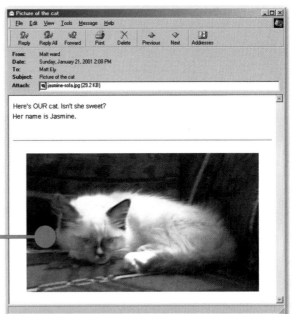

store images online

Use the Web to show off your pictures

Web sites are like big electronic billboards that you can use to show off your pictures to friends, family, and even total strangers. And though creating a Web site and posting pictures used to be tough work, now it's something you can do in minutes. That's because you don't have to make your own site at all—you can use one of the many photo-sharing sites on the Internet to **upload** (forward your pictures from your PC to the Web) and display your pictures.

Web sites like clubphoto.com store your photos for you.

Photo-sharing Web sites are a great way to display your pictures so acquaintances can check out your work anytime they want to. In general, photo-sharing sites are free, and there's usually no limit to how many pictures you can store there. They make their money through a combination of advertising and special premium services. (For instance, you can order prints of pictures you upload to the site.)

The way you upload your pictures varies from one site to another, but in general you use one or more of these techniques.

■ Thanks to a special feature at the site, you simply drag picture files into a special place on the Web page itself.

■ Install a program on your hard drive that you download from the Web site you want to use. You choose the files to upload and they are copied to the Web site.

■ You send an e-mail to the Web site with the pictures as attachments, as if you were e-mailing the pictures to a friend.

After you transfer your pictures to the Web site using one of these techniques, you can give the pictures names and captions and then invite people to view them.

SK THE EXPERTS

What are some photo-sharing sites I can try?

There are a lot of them, but some of the most popular include Club Photo (**clubphoto.com)**, PhotoLoft (**www.photoloft.com**), and Ofoto (**ofoto.com**).

How can I keep strangers from getting into my personal photos on the Web?

Most photo-sharing sites include privacy features. If you want to prohibit most people from accessing your picture collection, you can password protect your pix. If you do that, though, you'll need to send the password to anyone that you want to invite into your photo albums.

Do all my pictures end up in one big, messy collection?

No. You can organize them into separate folders, just as you might store different 35-mm prints in different photo books. How you organize your pictures is generally up to you.

I'm concerned that people might steal my pictures if I post them to a Web site.

By taking a picture, you have automatic copyright protection—which means it's illegal for anyone to use your pictures without your permission. Does that mean it won't happen? No, not really. One way to prevent people from stealing your photos is to size them small enough that they're not particularly useful for anything. If you upload a 640 x 480-pixel image, it's a tempting steal. If you post a 320 x 240-pixel picture, they can still steal it—but it's probably too small to be worth their while. Why? Because if they attempt to enlarge it, the resolution (clarity) will be so poor it will be seriously ugly.

give away images on CD

Wouldn't it be great if you could copy your photos onto a CD that can be popped into any computer's CD-ROM drive for viewing? Now you can! All you need is something called a CD-RW drive (also known as a CD burner) which costs about $200 and is available at most computer stores. Don't forget to get some blank CDs, which cost less than a dollar a piece. One CD holds 650MB of data—that can be as many as a thousand decent-sized pictures! No wonder storing and sharing pictures on a CD is so darned attractive.

There are two ways to create your own CD-ROM photo albums. It all depends upon how much time and effort you want to invest in the project.

Just copy pictures to the CD Use the software that came with your CD-RW drive (probably a program like Roxio's Easy CD Creator) to drag and drop pictures from your hard drive to the CD-RW drive. (Remember, the CD-RW drive is different from the regular CD-ROM drive. It lets you not only play disks, but also copy data to them.) When you're done, click the button to create your CD. The disadvantage is that whomever you send the CD to will have a disk filled with dozens or even hundreds of pictures and no easy way to navigate around. It's a bit clumsy.

Use a multimedia program like Flip Album CD Maker Software like this is custom-designed to let you make a colorful, informative, and interactive photo album on the CD that you can give to your friends.

ASK THE EXPERTS

Can't I copy images using my CD-ROM drive?

No, CD-ROM drives don't have the technology to let you record information onto them. You need a CD-RW drive (RW means read/write) for that. Good news: a number of new computers are now shipping with internal CD-RW drives that let you read CD-ROMs and listen to audio CDs, as well as make CD-R disks.

Can people that I give a CD to change or delete the pictures on the disk?

They can if you give them a CD-RW disk, which can be changed just like a floppy disk. If you use a CD-R disk, though, (the R means recordable) the contents can't be changed, so it's more secure. Even better, CD-R disks are cheaper and can be read on CD-ROM drives, so it's a win-win situation. If you have a photo circle going, though, in which you send a disk to friends who add their pictures and send it back to you, you'll all need to use a CD-RW disk.

If I copy pictures to a CD, how does someone see the images I store there?

If you put JPEG, BMP, TIFF, or other common file formats on the disk, they should simply double-click to see the images—it's that easy. They don't need any special imaging software. Windows has built-in viewers that can read most common image file formats.

Does it matter what kind of CD-R disk I buy? They seem to come in a lot of different varieties.

These days, it doesn't really matter. The more you buy, the cheaper they come—you get a discount for buying in bulk. At some computer stores, you can sometimes find a box of 50 CD-Rs for under $10, in fact. CD-Rs also come in a variety of speeds, like 4X, 8X, and 12X. Just make sure that the disks you buy are at least as fast as your CD-RW drive. So get 8X or 12X disks for an 8X CD-RW drive. Some music stores charge a premium for CD-R disks, so they're probably not the best places to buy them. As mama said, shop around.

view images on TV

Smile, you're on television!

For displaying your pictures to a lot of people at once, nothing beats showing them off on television. Most digital cameras come with a video-out jack that you can use to connect your camera to a TVset.

To use this cool feature, just connect the video cable (it should have come with the camera) from the camera to your television's composite video input. You can also plug it into your VCR—whichever is easier. Then set the TV or VCR to its external input mode. (You'll have to consult your manual to know how to do this—these features vary from set to set.) Turn on your camera and set it to playback mode, not record. Your images should appear on the TV.

Here's another nifty tip. Few people realize that you can copy images from your computer's hard drive to a memory card (see page 18). Start with a blank memory card and insert it in your camera or memory-card adapter. If you are using your camera, connect it to your PC, and using your camera's image-transfer software, just copy the images you like from the PC to the memory card. This trick turns your camera into a pocket-size slide projector that you can later use to show pictures on any TV.

HAT IF

Your TV only has an S-Video connector?

An S-video connector offers a higher-quality connection than composite and is found in most decent home entertainment centers today. Not to worry. Head over to a local store and pick up an S-Video-to-composite adapter.

Your camera doesn't have a video-out feature?

You're probably out of luck. On the other hand, your computer might have a video-out port on the back, near the video card slot. If it does, you can connect your computer to the television instead. You can even add a video-out adapter to your PC for just a few dollars.

You connect the camera to the TV but don't see the pictures?

There could be a few things wrong. First, make sure the camera is turned on and set to the image-playback mode. If that's okay, make sure the signal is set to the correct external input—some video systems have several video inputs. Lastly, if there's both an S-Video and a composite video input on your TV or VCR, pull out the S-Video cable. On most systems, anything plugged into the S-Video port of a TV or VCR overrides the composite input.

put pictures in a digital picture frame

It's like a regular picture frame, only you plug it in

They're all the rage—digital picture frames that plug into any electrical outlet. Put one on a tabletop in your family room, and it'll run a slide show of your favorite digital pictures all day long. Digital picture frames are a great addition to a digital camera family because you can show off your images without printing them. And they're a great little conversation piece.

Most digital picture frames have a memory slot that accepts memory formats (cards) like Compact Flash, SmartMedia, or Memory Sticks. Just remove the memory card from your camera or memory-card adapter, insert it into the digital picture frame, and the images start playing. You can set what hours they run, and they'll turn themselves on and off at the appropriate times each day.

A digital picture frame let's you show off your digital photos.

ceiva

Digital picture frames are convenient, but they have their limitations too. Most frames are hard to see in direct sunlight, and their fixed orientation makes it hard to show off landscape-oriented photos (those where the horizontal side is longest), for instance, if your frame is standing in portrait mode (where the vertical side is longest). You'll also need to position your frame near an electrical outlet, of course—something you never need to worry about with normal picture frames.

HAT'S OUT THERE

There are several popular digital picture frames on the market.

Digi-Frame These stylish-looking frames come in several sizes, from 4-inch displays to enormous 10.4-inch displays. They include Compact Flash and SmartMedia slots, and some frames even have Ethernet for networking your pictures directly from a PC. A Digi-Frame costs about $350.

Ceiva frames are a bit unusual—instead of conventional memory card slots, these frames connect to the Internet via a phone cord. You upload your pictures from your PC to the Ceiva Web site, and then Ceiva dials in daily to download new pictures (even pictures from friends, if you like). A Ceiva frame costs about $200.

Kodak Smart Picture Frame This frame is a cross between a standard memory-card-fed frame and the Ceiva. It features both a Compact Flash card for directly inserting images from your camera and connectivity to the Internet for downloading images. Kodak's frame costs $350.

Sony CyberFrame This frame is notable in that it uses the Sony Memory Stick to display images—so if you have a Sony digital camera, this is the frame for you. It will cost about $900.

store images on a PDA

Your handheld organizer can display images

In the old days, people would whip out a wallet to show off pictures of their spouse, kids, or cat. In the future, people will wave their arms and holograms of those subjects will materialize in thin air. In between these two technological eras we have handheld personal digital assistants, or **PDA**s, such as a Palm or Visor.

You may think of these electronic marvels merely as good places for displaying your calendar and contacts. But they can also hold photo album software that you can use to show pictures from your digital camera. One of the easiest photo albums to use is a program called Album ToGo. Album ToGo software is available at no charge from the Club Photo Web site (**www.clubphoto.com**). Once it's installed on your PC, you can drag images into the Album ToGo interface, customize them for your handheld device, and then transfer them automatically at the next HotSync. (HotSync is when you synchronize the PDA with your desktop PC.) If you have a color model, displaying pictures on it is too much fun to pass up.

Some personal digital assistants or PDAs let you view your digital photos.

ASK THE EXPERTS

How much memory should my PDA have?

Images on handheld devices are pretty small and usually clock in between 10KB (KB means kilobyte, or a thousand tiny units of information) and 50KB. That's not much, but even a few images will quickly clog up a 2MB (that's two meagabytes, or two million units of information) PDA. If you like the idea of storing images on your handheld, get one with 8MB of RAM (memory), or upgrade your device with expansion memory.

Can I show movies on my PDA, too?

Yes. If your camera takes short MPEG movies, you can convert them to a format that can be shown on your PDA, using software like FirePad or MGI PhotoSuite.

How do I use Album ToGo with my PDA?

The Album ToGo software is very easy to use. Just drag and drop an image from your hard drive to the Album ToGo interface. Then drag it around in the window until you see just the part that you want to appear on your handheld's small screen. Change the brightness and contrast if you need to, and then click the button marked Send To HotSync. On the Palm or Visor, you can choose individual images to display just by tapping, or run a slide show of all the pictures, complete with fancy transitions. You can also manage your pictures from this screen—you can rename, delete, or beam them to another PDA device.

now what do I do?

Answers to common questions

Do I have to resize my photos, or can I just upload a three-megapixel (three million pixels, or tiny dots) picture to the Web since that'll save me some time?

It might save you some time in the beginning, but it'll make life miserable for anyone who tries to view that picture on the Web. A three-megapixel image is huge on the computer screen—you have to scroll around with the mouse to see it all—and it takes a long time to display using slow telephone Internet connections. Save everyone some heartache and shrink your images right away.

Can I use the Resize tool in my paint program to make a picture bigger instead of smaller?

Technically, sure. You can resize images bigger or smaller. But you really shouldn't. When you resize a picture upward, it becomes blocky, blurry, and ugly. You really won't like the results. One exception—you can use a program called Genuine Fractals (see Chapter 8 for details) to moderately enlarge images and still get decent results.

If I use an online photo-sharing site and they charge a monthly fee, can I trust them? I'm worried about my credit card.

In general, Web sites are every bit as secure as the local store. Make sure that the site uses a secure Web page (you should see a little lock or security key in your Web browser's status bar when you are on the purchase page). Online stores go out of their way to ensure their sites are safe for consumers. And in any case, your credit card limits your liability for fraudulent charges.

If I put pictures on a CD, will the pictures automatically start displaying when someone puts the CD in their computer?

That depends. If you simply copy pictures to the disk, then no—they'll have to double-click on the CD's icon and look at the images manually. But if you use a special multimedia photo-display program like Flip Album CD Maker to make the disk, then the photo program can be set to start automatically when the CD is popped into the PC.

If I send a picture to someone in an e-mail, can they send that picture to someone else without my knowledge?

Yes. You can easily forward an e-mail message to anyone on earth without the original sender ever knowing a thing. E-mail is inherently not secure. But if you don't want your mail to be quite that accessible, you can use a secure e-mail program. These special programs let you determine whether mail can be forwarded, saved, or even printed. SafeMessage and Disappearing E-mail are two programs that give you more control over the e-mail you send. Disappearing E-mail is free; SafeMessage costs $100 a year.

I want to get all those pictures out of my wallet. What handheld organizers can I use to show off my pictures?

Any device that runs the Palm operating system can use a program like Album ToGo. That's any Palm III, Palm V, Palm VII, m105, m500, or m505. And the Sony Clie and Handspring Visor have exactly the same capabilities. Pocket PCs like the HP Jornada and Compaq iPAQ can show off pictures as well, even though they don't run the Palm operating system.

 NOW WHERE DO I GO?!

CONTACTS

Disappearing E-mail
www.disappearing.com

SafeMessage
www.safemessage.com

ClubPhoto
www.clubphoto.com

PhotoLoft
www.photoloft.com

ememories
www.ememories.com

Flip Album CD Maker
www.ebooksys.com

Digi-Frame
www.digi-frame.com

Ceiva
www.ceiva.com

Kodak Smart Picture Frame
www.kodak.com

PUBLICATIONS

I'm on the Internet, Now What?!
By Matt Lake

The Everything Build Your Own Home Page Book: Create a Site You'll Be Proud Of, Without Becoming a Programmer
By Mark Binder

CHAPTER 8

Printing
your pictures

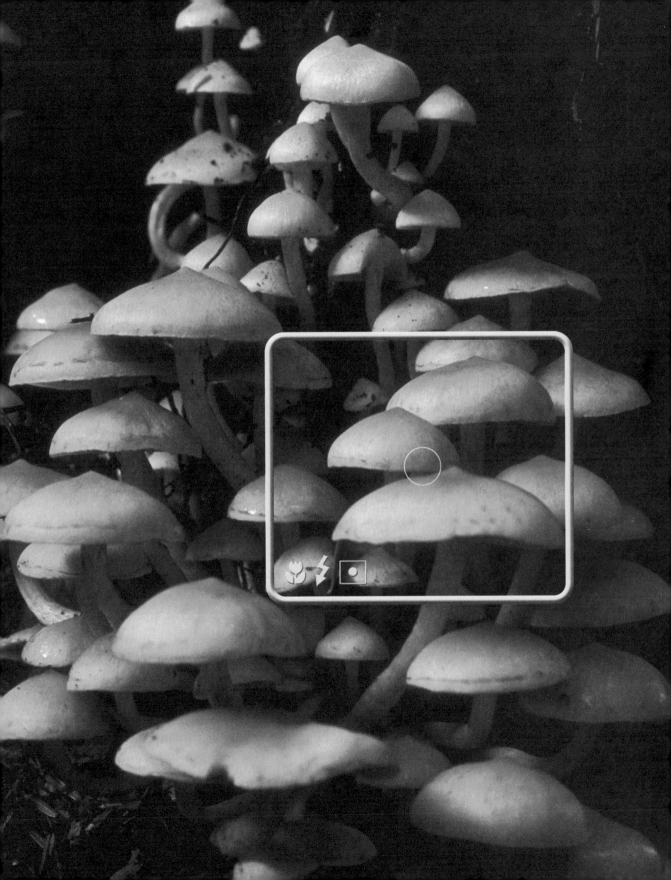

choosing a color printer

Which is the right model for you?

Your printer is what makes digital images come alive. With a photo-quality printer, you can operate your own photo shop. You get to choose, crop, and print your own pictures. It's enough power to make you feel giddy.

If you haven't bought yourself a color printer yet, you've got a lot of choices. The most common models are **inkjet printers**, so named because they squirt microscopic blobs of ink onto paper to make a picture. Quality inkjets—printers that are described as photo printers—use four or more colors of ink and create prints that are virtually indistinguishable from photographs.

A good color printer lets you create your own photo prints.

In general, the more inks that a printer uses, the better the image quality. You may see printers that have six or even seven individual ink cartridges. With more shades to work with, these printers create better skin tones in prints. Whatever you do, don't settle for a 3-color printer. These models mix all the colors to make black, and the result is a grayish mess.

Some printers are called **dye sublimation printers**, and their output is even better. Using long ribbons of ink, dye sub printers create true continuous tones—not dots of different colors—and are the best of the best in computer printing. The problem? Dye sub printers are more expensive than inkjets, and they can't print images larger than 8 x 10 inches.

You might also be interested in a **laser printer**. Lasers create sharp, crisp text and detailed graphics, but affordable models only print in black and white. Color laser printers cost a few thousand dollars and a quality inkjet generally prints better pictures anyway. If you print a lot of text, you might consider getting an affordable black-and-white laser as a second printer.

SK THE EXPERTS

What specifications or features should I look for when I shop for a printer?

Resolution (the number of pixels, which will determine the clarity of the image) is always important. Better inkjets will advertise a resolution in the neighborhood of 1440 dots per inch, or dpi. And though you may want a fast printer, higher quality prints are always more important than getting your prints fast. You should also buy a printer that can generate the right size prints—you may want oversized enlargements, like 11 x 17 inches. If you do, you'll need a wide-format printer. Likewise, don't settle for a budget dye sublimation printer that can only do 5 x 7 prints if you want 8 x 10s.

Is there a difference between USB and parallel port printers?

No. They work the same, except they use different **ports** (the holes in the back of your computer) to connect to your computer. Older computers (Windows 95) have parallel ports to connect up to a printer. To be compatible, older printers used parallel ports. Then the technology changed and USB ports arrived, and all new computers (Windows 98 and later) use USB, so the printers had to switch and use USB too. A few printers include both ports, so you have a choice. Otherwise, you can buy a USB adapter to fit a parallel port, so your new printer can work with your old computer.

Will everything that I need come with the printer?

You'll get one set of ink cartridges, good for between 25 and 50 prints. You may also get some sample paper and a few graphics programs. What you probably won't get is a printer cable—the parallel or USB cable—which you'll have to buy separately to get everything connected. Check the box carefully for what's included before you go home from the computer store. Otherwise you might have to turn around and go back for a silly cable.

select the right paper

Not just any old paper will do

It happens all the time. Someone—let's call him Jim—goes to the store and sees a folder full of absolutely amazing pictures. "This printer printed these?" Jim asks, astounded that a $200 printer could generate prints so breathtaking, so sharp and colorful, so devoid of those little jagged edges and pixels that everyone always associates with computers.

So Jim buys the printer, takes it home and sets it up. He takes his favorite digital image and prints it. The result? An ugly, muddy mess. The paper warps and bends as if it got too wet, the colors are weak and run together, and the picture looks more like a watercol-or portrait than a photo-quality print.

The lesson? The type of paper that you use has as much to do with the print quality as the particular printer you use. Maybe more. A $99 printer and a $1000 printer will give you essentially the same awful results if you use plain paper to print. Buy several kinds of paper, experiment to see which ones give you the best results, and use the premium photo-quality paper whenever you're printing something that you plan to frame or give away.

HAT'S OUT THERE

Plain paper Plain paper is good for printing day-to-day text documents and ordinary graphics printing. The paper is inexpensive, but when printing pictures, the ink gets absorbed quickly into the paper and blurs your image. The paper also curls and distorts.

High-quality or coated paper This is one step up from plain paper. High-quality paper is usually made with special clays embedded in the paper to stop the inks from spreading before they dry. For printing plain text, you probably won't notice a big difference, but this paper improves photographic prints.

Photo paper A variation of coated paper, photo paper is generally bright-white coated paper that's designed explicitly for photographs. If you're looking for paper in an intermediate price range that can give decent results, try this stuff.

Glossy photo paper The best paper around, glossy stock is expensive, generally costing about a dollar a sheet. Sure, you won't use it all the time, but if you plan to frame a picture or give your digital prints away to family or friends, definitely try this special photo paper. You can only print on one side of glossy photo paper; the back side looks like the back of a photograph and usually has a logo printed there.

Specialty paper There are a lot of specialty papers in computer and office supply stores; look around for something you like. Fabric papers are pretty popular, for instance; they have a texture that you can use for its own sake or to make cross-stitch designs and other craft projects.

use the right resolution

A picture is worth a million pixels

Modern art is wonderful, but odds are that you don't want your carefully photographed portrait to look like a few splotches of red with perhaps a hint of blue. Instead, you want your digital images to print with as much color, sharpness, and clarity as any 35-mm print you get from the corner photo shop.

The key is often resolution. As you know by now, the resolution, or clarity, of your picture is determined by the number of pixels, or tiny dots, that make up the image. You need to send the right number of pixels to the printer for whatever size print you intend to make. You may remember that you can't make an 8 x 10-inch print from a one-megapixel image, because even one million pixels aren't enough to make a quality print in that size. When you take your pictures, you should set your camera to the resolution that will later allow you to print the size you want. If you change your mind later, remember that it's easier to resize downward than it is upward. The Resize tool in image-editing software lets you see what the current resolution is and lets you set your intended resolution. Here is a handy guide to matching the right resolution to whatever print size you want to make.

Pixel Size	Megapixel equivalent	Ideal print size
700 x 400	less than one megapixel	wallet size
600 x 1000	less than one megapixel	3 x 5
800 x 1200	one megapixel	4 x 6
1600 x 2000	three megapixel	8 x 10
2200 x 3400	six megapixel	11 x 17

 SK THE EXPERTS

Is there a rule of thumb I can use to decide how many pixels I need for a given print size?

Yes. If you are printing on an inkjet printer, figure on about 200 pixels per inch. For a laser printer, use 300 pixels per inch. Suppose you want to make a 3 x 5-inch print. The image should be 600 x 1000 pixels if you're using an inkjet or 900 x 1500 pixels if you're printing with a laser printer.

If I have a collection of pictures taken at my camera's highest 3-megapixel resolution, can I print them at small sizes like 5x7 inches? Or do I need to reduce the resolution before printing?

You certainly can go ahead and print them without resizing. But consider this: sending a 3-megapixel image to your printer may slow down the print process, and if you're actually including the picture in another program, you'll use up a lot of memory and disk space as well. So it's not a bad idea to match the pixel size to the print size by resizing whenever possible. (For how to do this, see Chapter 7.)

My inkjet printer claims to have a resolution of 1440 dpi, or dots per inch. Should I use that number when calculating picture size?

No, the advertised resolution of an inkjet printer has little to do with the ideal image size you start with. A good rule of thumb is 200 dpi (or dots per inch), no matter what the printer's spec sheet says.

making the print

Time to press the print button

The proof, as they say, is in the printing. The exact details will vary depending upon which program you use, but in general the procedure is pretty straightforward. Start by opening the image in the program you plan to print with. Resize the image to match the print size you want (see chart on page 162), and click Print.

Of course, before you print your picture, you'll also want to orient it so the image prints the right way on the paper—landscape (horizontal orientation) or portrait (vertical orientation). You should also change the size of the image so it fills the paper the way you want it to.

You should also make sure the printer itself is configured properly before you print. Be especially careful that the printer knows what kind of paper it is getting; it'll treat a special paper like a coated, premium photo paper much differently than it would plain copier paper. There are other printer features you may be able to customize; check your printer's users guide to see what you can do with your printer.

Before you print, check the setup, output, and preview settings. Then select the kind of paper you want to print on.

STEP BY STEP: PRINTING FROM PAINT SHOP PRO

The printing process is essentially the same regardless of what program you use, but we'll use Paint Shop Pro for this example. Suppose you're going to make a print at 8 x 10 inches. Do the following steps.

1. Open the picture in Paint Shop Pro.

2. Select the paper size and orientation. Choose File and Page Setup from the menu. You should see the Page Setup dialog box.

3. Click the Portrait or Landscape button in the Orientation section of the dialog box to orient the picture vertically or horizontally.

4. In the Size menu, choose Letter $8\frac{1}{2}$ x 11 in.

5. You can reduce the margins in the Position dialog box to squeeze more picture into the page. (Print programs use a margin, like 1 inch, and they won't let you print the image any bigger if it interferes with the margin. So you can tell the program to use a smaller margin, allowing you to fill up more of the paper with your picture.)

6. Click the Fit to Page box. You should see the preview of the image snap to fill most of the page.

7. Click OK to close the Page Setup dialog box.

8. Select File, then Print.

9. Click Properties next to your selected printer. Select the correct type of paper—if this is going to be framed and hung on your wall, for instance, you probably want to select a glossy or premium paper.

10. Load the paper into your printer. Make sure that you put it in with the appropriate side set for printing, and only load a single sheet at a time.

11. Click OK to begin printing. When the paper comes out of the printer, let it dry for several minutes—otherwise you could smudge it.

enlargements

Suitable for framing! **N**othing beats decorating your living room with an 8 x 10-inch print that you took yourself. And prints like that are even more rewarding when you've cropped, enhanced, and printed them yourself. You've already learned how to crop (see page 102) and size (see page 138) prints, and you also know how to configure your printer for the job.

But often, you'll start with images that are simply too small for enlargement duty. If you want to make a large print—like 8 x 10 or 11 x 17 inches—you can't resize your picture larger and expect to get good results. Instead, it'll look blocky and ugly. Here's where you will need some software. A program like Genuine Fractals has the technology needed to enlarge a digital image while preserving image quality. It uses a sophisticated process to smooth out your image and make it possible to get good results printing pictures two, three, or even four times bigger than the 200 dpi rule of thumb would ordinarily allow. The software costs about $160, but you can download a free trial at **www.altamira-group.com**.

To use the program, you simply save your image as a Genuine Fractals file (it has its own file type) from your image editor's Save As dialog box. Then open the Genuine Fractals version of your image at whatever resolution you want to use for printing. It's that easy, and the results are quite impressive.

STEP BY STEP: PRINT AN ENLARGEMENT WITH GENUINE FRACTALS

After you've installed Genuine Fractals on your computer, follow these steps to print an oversized picture with the software.

1. Open the picture into your image-editing program.

2. Choose File, Save As to see the Save As dialog box. In the Save as Type menu, choose Genuine Fractals (.stn, .fif). Click Save.

3. The Genuine Fractals Options window should appear. Click Lossless from the encoding options and then click Save.

4. Close the image. It has now been saved as a Genuine Fractals image.

5. Load the Genuine Fractals version of the image into your image-editing program.

6. You should immediately see the Genuine Fractals Options dialog box. In the Scale To section of the window, enter the number of pixels you'd like the image to have. If you need to, use the 200-dots-per-inch rule.

7. Click the Open button to load the enlarged image into your image editor.

8. You're ready to print the image. Load your paper, set the printer's preferences, and set the print options to print your enlargement.

using a printing service

Let someone else do it

Just because you have a digital camera, that doesn't mean you have to say good-bye to the convenience of ordering prints as you used to do with the ones from your old 35-mm camera. In fact, there are a lot of ways to order prints of digital pictures easily and conveniently.

Many local photo developers offer digital-image-printing services, for instance. If you live near a photo shop that you already like, just go in and ask them if they print digital images. Odds are good that they'll say yes. Find out what form they need the images in. It's probably as easy as dropping off a floppy disk, CD-R (see page 146), Zip disk (see page 90), or camera memory card (see page 19).

You might also want to use a photo-printing Web site. Many of the photo-sharing Web sites you've already read about make their money by printing digital images for you. Some popular Web sites that print your images include:

ezprints.com

shutterfly.com

clubphoto.com

photoloft.com

Using these Web sites is easy. Just upload or send your pictures to their Internet site as if you were going to display them, except this time you also have to fill out a simple form, supply a credit card number, and wait for your prints to arrive. You can even specify whom to send the pictures to—so you can automatically send a batch of holiday prints to your entire family.

ASK THE EXPERTS

How large can these Web sites print my pictures?

In general, as large as you like—all the way up to poster size. They'll warn you if you're trying to print a picture too large and it won't look good.

Do these sites also develop 35-mm pictures?

Many of them do, yes. You can mail them your undeveloped roll of 35-mm film, and they'll post digital versions of the pictures on the Web site. You can then pick which pictures you want printed, and they'll send them directly to you.

How does the print quality compare to 35 mm?

It's quite similar. You might want to do some comparison shopping, though. As with any photo developer, quality varies from one shop to another, and you may be happier with the color balance and printing quality at one Web site and less thrilled with the results at another.

Can these sites make greeting cards, mugs, and other specialty items?

Absolutely. Many sites can print your pictures on those items and more—like T-shirts and baked goods. That's right, **clubphoto.com** can turn your pictures into Rice Krispies cookies and chocolate photo cards!

caring for digital prints

**Make your prints
last forever, almost**

Did you know that ordinary 35-mm prints—the kind you get from the local photo shop as well as the ones that you get from professional portrait photographers—don't last more than 20 or 30 years? All photos fade; it's just a matter of time.

So too do digital prints. Until recently, digital prints faded a lot faster. Newer printers with better ink formulas and long-lasting paper, though, have become popular and offer greater longevity. With some of the newest inkjet printers, you can make prints that last for 100 years without fading. That's actually a better life span than you can get with traditional prints!

You have to treat your photos right, though, to get the most life out of them. With the proper care, your prints will outlast you. Here's what you should do to extend the life of your prints.

- Get your pictures under glass or plastic. Some inks fade quickly when exposed directly to air.

- Never get your prints wet.

- Avoid exposing your pictures to direct sunlight. Try to hang them on a wall that's usually in shade.

- If you're using a special paper, be sure to print your pictures on the proper side.

 ## Ask the Experts

Can special glass help protect my pictures from sunlight?

Yes, UV-protected glass, which you can buy at many frame shops, can slow down sunlight-induced fading.

How do I make sure my printing setup is going to provide me with the longest picture life?

Your best bet, especially if you're using a new printer that is explicitly designed to offer a long picture life (called **light-fastness** in photo jargon), is to use the ink and paper designed expressly for the printer. Don't mix-and-match inks or paper to try to save money.

FIRST PERSON DISASTER STORY

Keep It Under Wraps

Friends of mine had remarked how much they liked some pictures I had taken on our recent vacation to Colorado. Thinking that they'd really enjoy having some photographs of Garden of the Gods and Pikes Peak, I printed a half dozen of my best shots as 8 x 10s using my Epson Stylus Photo 870 and mailed them off. About a month later, my friends remarked that the pictures had changed—while they were fine to begin with, they now looked all orange, as if the pictures were taken through a deep-colored filter! The problem, it seems, was that I used Epson's premium photo paper, which fades dramatically when exposed to the ozone in the air. Now when I send people my prints, I tell them to get the pictures mounted behind glass right away.

Tony S., Springville, New York

now what do I do?

Answers to common questions

There are so many kinds of paper in the office supply store, and they all have similar names. How can I figure out which ones are supposed to be better than others for printing photos?

Most paper manufacturers have quality guides that explain which paper lines are designed for what purposes. These guides are usually hung up near the paper so you can check them while paper shopping. Or you can check their Web sites. Barring that kind of research, heavy stock that looks like photo paper is the best of the bunch—always choose it for final prints. Paper that doesn't have that photograph look—even if it's described as photo paper—is best left behind.

I like my printer, but lately it has been generating spotty prints. Does it need to be repaired?

Most likely, the inkjet nozzles need to be cleaned. There should be a utility or maintenance setting in your printer's properties that you can use to automatically clean the nozzles. You may need to run the cleaning operation two or three times before the printer works right again.

Does it matter which side of the paper I print on?

Yes, it often does—especially on premium printer paper. Check the instructions that come with your paper to see how to load it into the printer. In general, you want to print on the shinier side of the paper. If you want to print on both sides of the paper, use printer paper that's designed for that.

I see inexpensive "refilled" ink cartridges for sale for my printer. They'd save me a lot of money—are they safe to use?

As tempting as it might be to use bargain-priced ink cartridges, you should avoid them. Here's why: your printer is designed to give excellent results when combined with a specially formulated ink and the right quality paper. Believe it or not, much of the time and money spent on printer research and development goes into the ink formula, not the printer! So if you put a generic refilled cartridge into your inkjet, you'll be defeating the very reason you shopped around and bought a good printer to begin with.

My printer used to work just fine, but now it gives me error messages when I try to print with it. What should I do?

It sounds as if you've installed something on your computer that is conflicting with the printer driver. The best bet is to repeat the printer installation process—find your old disks and reinstall the software program. Nine times out of ten, that'll fix your problem.

Can I connect one printer to more than one computer?

Yes, you can. If you have a home network, you can share a printer easily. If you don't have a network in your home, you might be tempted to try a switch box, which is a little device that connects one printer to two or more PCs. Avoid them. They used to be very popular and you can still find them in stores, but most modern printers don't work with them at all.

How do I trim prints, since the printer doesn't print right to the edge of the paper?

For outstanding results, use a paper cutter from an office supply store—you know, the kind where the blade comes down like a cleaver and you warn kids not to put their hands anywhere near it. (Watch out for your own fingers!) You can also use an X-acto knife, a straight edge (such as a ruler), and a cutting board.

OW WHERE DO I GO?!

CONTACTS	PUBLICATIONS
Epson www.epson.com	**The Color Printer Idea Book: 40 Really Cool and Useful Projects to Make with Any Color Printer!**
Hewlett-Packard www.hp.com	By Kay Hall
Canon www.usa.canon.com	
Lexmark www.lexmark.com	

CHAPTER 9

Cool accessories

add-on lenses

Expand your horizons with lenses

Your camera's 2x or 3x zoom lens is great for most ordinary photographic situations. But did you ever wish you could make the lens a bit wider—to capture a scenic landscape while on vacation or perhaps to shoot an entire room at a party? Or maybe you'd like a bit more reach from your zoom lens—to pull in distant subjects and magnify faraway objects.

If your inner artist yearns to explore more digicam effects, you don't need to buy a new camera with a longer zoom lens. Instead, consider purchasing an add-on lens that you can snap or screw onto your camera for special situations.

Most people don't realize that there are all kinds of add-on lenses available for many digital cameras. Check the front of your lens for screw threads. If you see them, then you can probably screw add-on lenses directly onto the front of your camera. If your camera's lens doesn't have screw threads, there may be a snap-on lens adapter available from your camera maker or from a lens company like Tiffen or Raynox. Add-on lenses can give you wide-angle, telephoto, and even macro photography (extreme close-up) capabilities that you never imagined your simple little digital camera could offer.

Make sure you know the brand and model of your camera when you go to buy your add-on lenses, though, because they're not compatible from brand to brand. You might also want to take your camera to the store, to try out the attachment and see if you like it.

HAT'S OUT THERE

Wide-Angle lenses are generally quite large—they make the lens flare out in front as if you screwed a hubcap on the front of the camera. But wide-angle lenses are great for compressing a lot of landscape into a single picture. On the downside, some lenses can introduce distortion, such as the fish-eye effect, where straight lines look curvy. A wide angle's x-power is always less than one, like .75x or .5x, since it's reducing the magnification of your lens system.

Telephoto lens attachments can double or triple the zoom power of your lens and come rated with x-powers like 1.5x and 2x. Unlike wide-angle lenses, telephoto attachments are long and look like miniature telescopes.

Close-Up lenses let you take extreme close-ups of small objects, like coins or bugs. You generally have to get very close to your subject for close-up lenses to focus properly, and they're described not with x-power numbers, but with measurements known as **diopters**, signified by numbers with a plus sign. Each lens is a single size, and a +10 close-up lens is more powerful than a +1 close-up lens. The bigger the number, the higher the magnification.

.65x wide angle

.75x wide angle

1.5x telephoto

177

using a tripod

Easy now—hold that camera steady

The number one cause of disappointing pictures is probably the easiest thing to correct—camera shake. Camera shake happens whenever the picture taker moves. Try as you might, it's almost impossible to hold a camera completely steady. Your hands will always shake a little, and if the camera's shutter is open too long, you'll make that motion a part of your picture in the form of blur or jitter.

Obviously, one way to solve the old camera-shake problem is to use a fast shutter speed. Shoot in bright daylight, for instance, with the camera left in automatic or program mode, and you won't usually have a problem. Setting your zoom to wide angle will also reduce the effect of camera shake. But what if you're shooting indoors, outdoors at dusk, or with a telephoto zoom that magnifies the effect of camera shake? You guessed it: use a tripod.

A **tripod**, which has three legs, comes in all shapes and sizes. You can get a tiny tabletop tripod that fits in your pocket, or a larger tripod that's better for shooting outdoors in the wind. Some people prefer monopods— monopods have only one leg, which you hold to steady your pictures. It's not as bulky or cumbersome as its three-legged sibling.

tripod

LEAN FOR SUPPORT

When you don't have a tripod handy to steady your shot, lean against a wall or doorway. It really works! You can use this trick to take steadier pictures in low-light situations with nothing but a door jamb and your shoulder.

Tripods Spend a little time with a salesperson in your local camera shop to see what kind of tripod is best for you. Keep in mind that since digital cameras are much smaller and lighter than 35-mm cameras, you can get by with a much smaller unit than many other photographers use.

Monopods They're good for adding a little stability to telephoto shots. They won't freeze action with a very slow shutter speed, but they're a good compromise between hand-holding a camera and carrying a bulky tripod.

Quick-Release Platforms All tripods use a standard quarter-inch screw mount. You will find a screw socket on the bottom of both your 35-mm camera and your digital camera. Many tripods use a quick-release platform. You can screw the quick release into the camera and leave it there, then snap or latch it into the tripod head when you're ready to take a picture. Quick releases make it dramatically easier to quickly connect the camera to a tripod when you need to take a picture. This is a very handy feature to look for when tripod shopping.

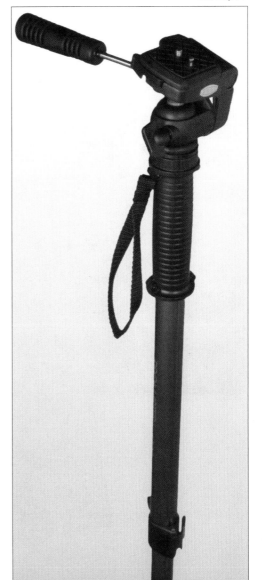

monopod

special filters

Easy ways to improve your pictures dramatically

People tend to think of photography as a science—as a means of documenting the world as it really looks. Nothing could be further from the truth.

In reality, photographers enhance their images all the time. The goal isn't to capture a scene the way it actually looks, but rather the way you want to remember it! To that end, there are filters available to make all sorts of minor changes and corrections to your pictures. Using filters, you can eliminate harsh reflections from the sun on glass or water, soften your subject's complexion, and more—much more.

Filters attach to the front of your camera in much the same way as you connect add-on lenses—they'll screw directly onto the front of your lens, or there is a filter-adapter kit available from your camera maker or a company like Tiffen. You can attach one or two filters to the front of almost any digital camera with the right adapter. But remember—the more filters you use at once, the less light you're letting into the lens. So try to stick with just one filter at a time.

A polarizing filter was used to eliminate glare from the photo on the far left.

HAT'S OUT THERE

UV Protection This is the most common filter for cameras; not only does it filter out the bluish cast caused by the UV in ordinary daylight, but it protects the front of your lens from everyday scratches. After all, which would you rather scratch and replace—the $10 filter or the $500 camera? It's a good way to protect your digital camera lens.

Polarizer This amazingly useful filter eliminates glare caused by sunlight reflecting off glass and water. This filter actually rotates, and you need to turn it while looking through the camera viewfinder until you see the reflections disappear—then leave the filter in that position and take the picture.

Neutral Density This filter's job is to block light. If you're trying to get motion blur in your picture—say you want to take a picture of a waterfall and you'd like the water to all blend together, but you can't slow the camera's shutter speed enough because it's too bright out—apply a neutral-density filter. It'll reduce light going into the camera and let you shoot with a slower shutter speed.

Soft Focus A popular tool on daytime soaps and old episodes of *Star Trek*, soft-focus filters slightly blur the subject. Use it on portraits to soften the complexion and create a more pleasing picture.

long-life batteries

Take more pictures without running out of juice

Unless you hardly ever haul your digital camera out of the closet, you should avoid using ordinary disposable alkaline batteries, because digital cameras use them up pretty fast. Instead, invest in a set of NiMH (Nickel Metal Hydride) rechargeable batteries.

Sure, rechargeables are initially a bit more expensive. But they quickly pay for themselves, since you can use rechargeable batteries over and over—a few hundred times on average. You can do the math yourself. Suppose that you use your camera every weekend for a year, and you have to replace the batteries (depending on the camera, that's 2 to 8 batteries) every other week. Here's how the cost stacks up over the course of one year alone.

AA Alkaline	**AA Rechargeable (NiMH)**
26 x $3 = $78	$35

The more you use your camera, the more obvious the cost savings become. And once you've bought your first set of rechargeable batteries, additional sets are less expensive because you don't have to buy the charger unit again. Additional sets of rechargeable batteries can be had for about $20 per pack of four.

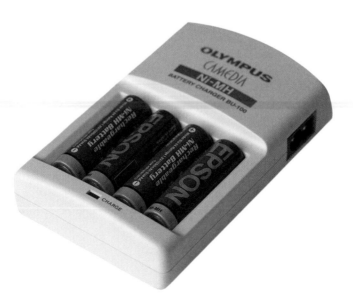

ASK THE EXPERTS

There are all sorts of rechargeable batteries. Which kind should I use in my digital camera?

Most cameras like batteries called NiMH, which is short for Nickel Metal Hydride. NiMH come in the same AA size as ordinary alkaline batteries, but they last longer and can be charged over and over.

Where can I buy rechargeable batteries?

Any store that sells home electronics should carry them. For starters, get a pack that includes a charging unit. If you buy more batteries later, you'll already have the charger—so just get packs of batteries.

Can I use the charger to charge alkaline batteries?

No! Only use the charger with the kind of battery it was designed for. That means you should never put alkaline, NiCad, Lithium, or nuclear-powered batteries in your NiMH battery charger, or you could—as the warning always says—risk "fire or explosion."

GETTING THE MOST OUT OF YOUR BATTERIES

To make your batteries last longer between charges, remember these tips.

- If your camera allows it, turn off the LCD display (the little TV screen at the back of the camera) and look through the optical finder, which takes little or no battery power to operate.
- Don't review your pictures on the camera. Do that at home on your computer.
- Disable the flash when you don't need it.
- Leave the camera on. If you're taking a lot of pictures in a brief time, it takes less power to leave the camera on than to turn it on and off over and over.

tools for panoramas

Gadgets that help you capture panoramic scenes

Intrigued by panoramic photographs? They look great, and add a fun new element to vacation shots of the Grand Canyon or the alien landing strip you accidentally stumbled across in the Nevada desert. And if you find yourself taking a lot of panoramas, you might find some accessories make the job easier.

There are a number of tools available that can aid and abet your panorama picture taking. You should have a tripod, for instance, to be sure your pictures are all uniformly level and true to the horizon. You'll find that it's easier to get good results that way than by holding your camera by hand.

While you're at it, though, you might want a panoramic head for the tripod. These special gadgets let you spin the camera in exact increments so you take images with just the right overlap.

And then there's the software. Armed with panorama-making software (see page 126), you can turn a series of photos into a panorama or a 360-degree interactive virtual-reality experience (see next page) without any effort at all. All you have to do is move the mouse and pan through the pictures.

TAKE SOME VR TOURS

The Web is filled with virtual-reality tours using the very same techniques and software that you can use on your own. If you'd like to take some virtual reality tours from the comfort of your own Web browser, try some of these links.

www.groupvr.com

www.taj-mahal.net

www.armchair-travel.com

QuickTime VR Authoring Studio This is Apple's own tool for stitching pictures together into a fully interactive virtual-reality environment that people can look around in. They see the scene you shot from every possible angle. It's an excellent alternative for the Macintosh to some of the PC software products listed back in Chapter 6.

IPIX If you're really serious about taking 360-degree virtual-reality photos, few products are better at it than IPIX. This kit includes a Nikon camera, tripod, fish-eye lens, and software. The neatest part about IPIX is that you can take a complete panorama with just two pictures, since the wide-angle lens captures so much real estate. (Just know you can only take panoramas with it. It doesn't come with a regular lens.)

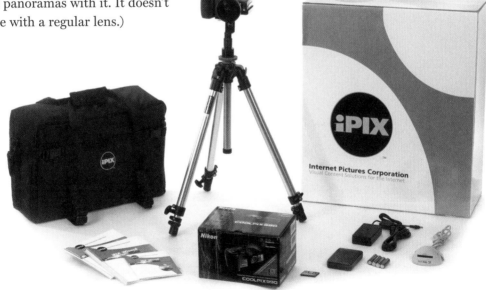

take pictures with your PDA

Your handheld can be a camera!

Do you own a Palm handheld PDA? If you do, you may have day-dreamed that, like some sort of James Bond spy gadget, it could also be turned into a camera. Actually, it can be. What you need is the Kodak PalmPix.

The PalmPix is a small gadget that snaps onto the tail end of your Palm. It has a small lens and no buttons or controls—it's operated entirely from the Palm. The Palm's own LCD display (mini TV screen) serves as the viewfinder and image-playback screen.

The PalmPix is a fun and genuinely useful tool for taking digital pictures on the go. If you already carry a Palm with you anyway, the PalmPix attachment lets you take pictures without lugging around additional gadgets. The PalmPix, in fact, weighs just two ounces with its pair of AAA batteries installed.

After you take pictures with the PalmPix, the images are automatically transferred to the PC when you perform an ordinary **HotSync** operation (that's when you press the HotSync button on your Palm and it synchronizes the data between your Palm and desktop PC). There's no messing with memory cards, connection cables, or memory adapters.

A PDA with a PalmPix attachment.

WHAT'S OUT THERE

If you carry around a Handspring Visor (another type of
handheld PDA that runs on the Palm operating system),
there is a digital camera accessory available for you as well.
The Visor includes a Springboard slot in back that serves as
a universal expansion slot—you can plug all sorts of things
into the Visor, like memory upgrades, a digital music player,
a wireless modem, and even a digital camera. Called the
EyeModule, this digital camera works a lot like the Kodak
PalmPix. It stores images on the Visor that are transferred
to your desktop computer when you synchronize with a
standard HotSync operation. Like the PalmPix, the
EyeModule is a clever way to turn something you already
carry around anyway—your PDA—into a digital camera.

KNOW ITS LIMITATIONS

The PalmPix is not a
megapixel camera that you
can use to take high-resolu-
tion 8 x 10-inch prints.
Instead, the PalmPix is a
good camera for posting
pictures to Web sites and e-
mail. That's why it captures
pictures in two resolutions—
320 x 240 and 640 x 480 pix-
els. The camera shoots and
stores images in color, even
if you are using a grayscale
Palm that can't display the
images in color. Attached to
an 8MB Palm (that's a Palm
with eight million bytes of
information), you can take
about 90 low-resolution or
20 high-resolution pics. The
camera features a 2x digital
zoom.

using a scanner

Want to clean up the scratches and creases in grandma's wedding portrait taken 100 years ago? Or perhaps superimpose a digital photo of you over an old photo of Elvis? It's easy to do with something called a **scanner**, a device that looks a lot like a home photocopy machine. A scanner will copy your picture electronically, meaning that it converts it into a computer file that you can store in your computer. How exactly is it done? Well, after the image is placed on the scanner surface and the light hits or passes through it, the image is converted into computer code and stored as a digital file in your computer. Computer folk refer to this image as the scanned image.

There are many different types of scanners, but flatbed scanners are the best for home use and the least expensive. You can buy a scanner at most computer stores. Scanners scan whatever you want, color or black and white. Key point: You can print out a color picture only if you have a color printer; if you have a monochrome printer (tech speak for black and white), your color picture will print out in black and white.

Flatbed scanners look like miniature copy machines. Just put your picture facedown, and presto, it's copied into your computer's hard drive.

TEP BY STEP: SCANNING

1. Turn on the scanner.

2. Turn on your computer.

3. Raise the scanner lid. Place the picture to be scanned facedown on the glass and close the lid. Take care not to scratch the glass.

4. Open the scanner software application on your computer. This assumes that you have already installed the software.

5. Tell the scanner what type of original art you are scanning by choosing Reflective for photographs or Transparency for slides.

6. Choose a Mode by selecting Grayscale or Color.

7. Choose a resolution: 72 dpi (low resolution, minimum detail, good for posting to the Web), 150-300 dpi (better detail, but the larger file takes time to open on the Web).

8. Choose a size: 100 percent is the default.

9. Click Preview. If you like what you see, click Scan.

10. Click Save. You will be asked to choose a file format (see below) and the destination, usually a folder on your hard drive.

Now a quick word about file formats—a technical term for how the art is stored. Your computer will offer you a lot of formats to choose from, but the best choice is JPEG for photographs and GIF for other color graphics. That's because most Windows programs and Web browsers can open these formats.

more software

Programs that help
you have more fun
with your camera

There are all sorts of programs that are designed to edit your pictures, display them for others to see, and add creative special effects. You've already seen many programs mentioned throughout this book. Here are some others you might want to check out when you have a chance.

Adobe Photoshop Elements A more user-friendly version of Adobe Photoshop, Elements is designed with just those tools that'll come in handy to put digital images in print and on the Web.

Roxio Easy CD Creator This is perhaps the easiest program in the universe for making your own CD-ROMs. If you have a CR-RW drive on your PC (see Chapter 7), try Easy CD Creator when you want to copy photos and other data to CDs.

ArcSoft PhotoFantasy A fun creativity program, this lets you combine your own photos with a variety of backgrounds and text effects.

Jasc QuickView Plus This handy little utility makes it a snap to view any kind of photo image or other data file without opening a big application. Just right-click on any file icon in Explorer Windows, choose QuickView from the menu, and you'll see a preview of the file right on the screen.

MGI PhotoSuite Mobile Edition This version of PhotoSuite lets you view photos and video on your PDA handheld organizer.

HAT IF

Your kids want easy and friendly software to create documents with text and pictures?

You can introduce them to your own word processor, like Microsoft Word or Corel WordPerfect. If you'd rather ease them into the world of word processing, try Creative Writer 2 from Microsoft. This kid-friendly word processor is light on advanced features that adults need, but it makes it easy for younger users to create documents and add pictures for eye-catching results.

You want to create greeting cards with your own digital images?

Use a program like CreataCard from American Greetings. There are actually several programs like this one available at most local software stores. They all let you import your own digital images into their greeting card templates for the ultimate in personalized holiday cards.

You want to make your own Web page?

Microsoft FrontPage comes with many new computers and it's in the box when you get Microsoft Office. It's a good full-featured choice. If that's more Web-page designer than you need, though, try Microsoft Publisher or Hotdog PageWhiz, a cool little Web-page designer that beginners have been using for years.

now what do I do?
Answers to common questions

Why isn't there a standard for digital camera lenses and filters? Why do they come in all different sizes?

That's a good question. Unfortunately, all cameras use different optics and the cameras themselves have different layouts, making any sort of standard impossible. It's nothing new, though. Add-on lenses and filters are all incompatible in the world of 35-mm photography as well.

How do I clean my camera lens?

Buy some lens tissue and a lens brush from your camera shop. Never wipe the lens on clothing or use your fingers to try to clean your lens—you'll scratch the lens and add a layer of skin oil to it that will make things even worse. To get rid of dust, use the lens brush to gently wipe it away. If you have more stubborn dirt on the lens, use the tissue to clean the lens gently in a circular pattern.

What should I pack in my camera bag when I go on vacation?

Bring a spare set of charged batteries and the charging unit. Carry a spare memory card if you can afford it, or a way to copy your pictures to a laptop or some other device. If you're serious about photography, have a tripod, polarizing filter, and some close-up lenses. Much more than that, though, and you'll start to wish you had a pack mule, too.

Are external flash units useful?

The flash that's built into your digital camera is good for about 10 or 15 feet under most situations. That's not a lot of range. And the flash's close proximity to the lens increases the odds that you'll get red-eye effects in your pictures of people. So if you can afford it and don't mind carrying some extra gear, an external flash is a good idea. Many digital cameras have a **hot-shoe connector** to attach a flash, or feature a connection-cord socket for a flash instead. (Hot shoe is simply a term from the world of traditional photography for the connector on the camera where you attach the flash. Usually, it's not even warm.)

What can I do with a remote control?

Some digital cameras have optional credit card–size remote controls. These devices are handy for triggering self-portraits or taking pictures when

it isn't convenient to be standing directly behind the camera—for example, if there is no room for you to stand there or you want to photograph something that is lying on the ground. You can also use remotes to play back pictures when you have the camera connected to a television (See Chapter 7).

Can I use my digital camera as a surveillance device around my house?

Yes. It's not terribly difficult to connect a digital camera to a PC and monitor your house remotely via the Internet. But you will need to leave the computer on all the time and leave the camera on as well—powered through an AC adapter, probably. You'll also need special webcam software that may come with your camera or that you can find on the Internet.

But there are easier ways to do this. A better bet is one of the several digital camera surveillance systems available from **X10.com**, a company that sells lots of consumer home automation products at very affordable prices. Another option is MiWatcher II from **goodysquare.com**, a small digital camera with an integrated modem that you can mount on any wall or ceiling. Just dial in from a remote location, like your office PC, to watch the action.

NOW WHERE DO I GO?!

CONTACTS	PUBLICATIONS
Apple **www.apple.com**	**Essentials of Digital Photography** by Akira Kasai
Raynox **www.digitaletc.com**	**Real World Digital Photography:** **Industrial-Strength Techniques** by Deke McClelland
Tiffen **www.tiffen.com**	

glossary

Airbrush
Just like a real airbrush that you can use to paint over the old kitchen wallpaper or eliminate graffiti, the airbrush tool in an image-editing program lets you paint over a picture with your choice of paint thickness and color.

Aperture
Like the human eye, a camera lens has an aperture that can open and close in response to how much light is available. In low light, the aperture will usually need to open wider to get enough light into the camera to properly expose the scene.

Application
This is a computer-speak term that refers to any computer program, like a game, word processor, image editor, or Web browser.

Attachment
E-mail was originally designed to send plain text, but these days you can "attach" other kinds of files to a message as well, such as picture files. (See also File Format.)

Background
When you paint with an image-editing program, you can usually specify two principal colors—the foreground and the background. To paint with the background color, you can press the right mouse button or use the eraser tool.

Bluescreen
A term that comes from Hollywood special effects, a bluescreen is a solid-colored background (it doesn't have to be blue) that you can use to digitally "replace"part of another image, making it look as though the actors are in a different location.

Byte
This is the standard unit of storage on a computer, sometimes called a "word." Typical computer files are measured in thousands or even millions of such words—hence the terms kilobyte (a thousand bytes) and megabyte (a million bytes).

CCD
A Charge Coupled Device (CCD) is the heart of a digital camera. It's the light-sensitive computer chip that "takes" the picture that's stored on a memory card.

CD-R
A CD-R disc is a recordable compact disk that you can use to duplicate other CDs or make copies of files. To record on a CD-R, you need a CD-RW drive. Once recorded, the information can't be changed.

CD-ROM
CD-ROMs look just like regular compact discs, but they have computer programs or files stored on them. You can't copy files onto a CD-ROM, you can only read them. (ROM means Read Only Memory.) CD-ROM can also refer to a CD-ROM drive, which is where you insert CD-ROM disks.

CD-RW Drive
A CD-RW drive can read data from a CD-ROM just like a CD-ROM drive, but it has the added advantage of being able to copy information onto a blank CD-R disk, or a CD-RW disk that can be re-recorded.

Clipboard
A special place in your computer's memory where you can store a copy of something, like a file or a piece of a digital image. When you copy data to the clipboard, you can later "paste" it somewhere else, for instance, onto another digital photo.

Clone
Using the clone tool in an image editor, you can quickly and easily duplicate one part of a picture in a different part of the image. By painting in this way, you can "erase" unwanted parts of a picture or add special effects like creating twins out of one of your kids.

Composite video
Most televisions and VCRs have a composite video connector where you can plug in your digital camera to view images on the TV screen. Composite video plugs are also called RCA-style plugs.

Copy and Paste
If you want to make a copy of something on your computer—like a part of a digital picture—you can copy it to the Windows clipboard. Usually, you can do this by selecting what you want to copy and choosing Edit, Copy from the program's menu bar. When you later choose Edit, Paste (it doesn't even have to be the same program), you'll make an exact duplicate of whatever you originally put on the clipboard.

Crop
When you crop an image, you are cutting away unwanted parts of the picture. You can crop a picture to change the orientation from portrait to landscape or just to trim away unimportant parts of a scene.

Depth of Field
The depth of field is the region in front of the camera that will be in sharp focus when you take a picture. Depth of field depends upon such variables as the shutter speed of the camera and the aperture setting of the lens. A big depth of field puts most of the picture in focus, while a shallow depth of field blurs most of the scene.

Desktop
In Windows, the desktop is the workspace on top of which all your programs open. When you first start Windows, before any programs start, the blank space is called the desktop.

Digital Camera (digicam)
A camera that uses a CCD and computer memory instead of film to expose and develop pictures.

Digital Film
Memory cards—like Compact Flash and SmartMedia—which your digital camera uses to store your pictures are sometimes called digital film.

Diopter
A term used to measure the amount of magnification generated by certain kinds of lenses. The larger the number, the greater the power of the lens.

Disk
A general term for any magnetic computer storage device. A hard disk drive is permanently enclosed in your computer. A floppy disk is a square palm-size removable disk. A CD disk resembles a large flattened donut.

f/Stop
The photographic term that refers to the size of the lens aperture. A small f/stop number (like f/2) is actually a large aperture setting, while a big f/stop number (like f/22) is a small lens opening.

File
Information that your computer programs use are stored in individual files. A digital picture is a file, as is a word processing document.

File Format

Your computer stores lots of different kinds of files—pictures, sounds, spreadsheets, and so on—and each different kind of file uses its own unique format. Picture files are identified by the three letter extension at the end of the file name, such as .jpg, .tif, and .eps.

Filter

There are two kinds of filters out there. Camera filters screw or snap onto the front of the lens to modify the picture. Plug-in filters are small computer programs that run inside your image editor and give your images special effects.

Focal Length

The focal length of your camera lens indicates how much it is able to magnify a scene. Short focal lengths are typically wide angle, while long focal lengths (telephoto) give you the ability to magnify faraway scenes.

Folder

Computer files are typically stored in folders on your computer's hard drive. A folder is also known as a directory, and it's just a convenient way to organize your data.

Foreground

When you paint with an image-editing program, you can usually specify two principal colors—the foreground and the background. To paint with the foreground color, press the left mouse button. To use the background color, press the right mouse button.

Gamma

The gamma control in an image-editing program lets you lighten or darken the mid-tones in a picture without ruining the brightest and darkest parts of the image.

Histogram

A graph that shows you the distribution of light and dark pixels throughout your picture.

Hot Shoe

A standard square mount on the top of many cameras into which you can slide an external flash.

Icon

Icons are the little pictures used by Windows and other computer programs to represent files, applications, and actions you can perform.

Image Editor

These programs display digital images and include some tools for modifying those pictures. Image editors usually let you resize, crop, paint, and print your pictures.

ISO

The world-wide standard for specifying film "speed," or sensitivity to light. ISO 64 film, for instance, needs to be exposed longer than ISO 400 film to capture the same image. Digital cameras don't use film, but they let you set the sensor's overall light sensitivity using the familiar ISO numbers.

Landscape Orientation

When a rectangular picture is oriented horizontally, it's called landscape orientation.

LCD

Most digital cameras use a Liquid Crystal Display (LCD) on the camera back as a digital viewfinder. The LCD also gives you access to camera menus.

Macro

Your digital camera's macro mode takes high-magnification close-ups. Add-on macro lenses can help you magnify small objects even more.

Megabyte

A million bytes, this is roughly the amount of data that a floppy disk can hold.

Megapixel

Cameras measure their resolution in how many pixels their pictures can hold. A one-megapixel camera is fairly low resolution, only able to generate high quality prints up to about 4 x 6-inches. Most high-quality cameras today capture about 3 megapixel images.

Memory Card

Most digital cameras use removable memory cards to store pictures. Memory cards come in a variety of formats, like Compact Flash, SmartMedia, and Memory Stick. You need to use the kind of card that fits your camera.

Menu

Available by buttons at the top of almost every Windows program, menus give you access to all of the controls and settings of the program. You use the left mouse button to select menu items.

NiMH

The most popular kind of rechargeable battery, Nickel Metal Hydride (NiMH) batteries can be charged hundreds of times, making them very cost effective.

Palette

Image editors use a color palette to let you choose colors for painting and editing. You can choose any of millions of colors for the foreground and background painting colors.

Palm

Palm is a popular handheld computer, also known as a personal digital assistant (PDA). These pocket-sized organizers can also run thousands of add-on programs. You can display digital images on a Palm instead of carrying pictures in a wallet.

Pixel

The smallest part of any computer image, pixel stands for picture element. A typical digital image is made from a grid of, say, 640 pixels across the screen by 480 pixels down.

Plug-in Filters

Plug-in filters are small add-on computer programs that run inside your image editor. Plug-ins make it possible to add special effects like blur, sharpening, false color, or hundreds of other effects to your pictures.

Portrait Orientation

When a picture is oriented so it's tall instead of wide, it's in portrait orientation. Typically, you need to turn your camera 90 degrees to take a picture in portrait mode, and you'll need to rotate the on screen image in an image editor to make it look right.

Range finder

With a range-finder camera, you don't look through the camera's lens to take the picture. These cameras are sometimes also called "point and shoot."

Red-Eye

This is an effect that can happen when you use a flash in a dark room. The light reflects off the subject's eyes and looks red. You can use red-eye reduction on the flash or in software to correct this problem.

Resample

When you resize a picture in an image editor to make it larger or smaller, you're resampling it.

Resolution

A measure of the quality of a picture. With a digital camera, resolution is measured by how many pixels the camera generates when taking a picture —the more pixels, the higher the resolution.

Sharpening

Sharpening is the process used by a plug-in filter to increase the apparent sharpness in a digital image.

Shutter Speed

Cameras can vary the amount of time that the lens allows light to reach the CCD. This exposure time is governed by the shutter speed.

SLR

Unlike a range-finder camera, Single Lens Reflex (SLR) cameras let you see exactly what you're about to photograph by letting you peer through the lens.

Stitching

Stitching refers to the process of attaching several images side by side to make a panoramic photograph. Stitching can be done manually in an image editor or automatically with specialized software.

S-Video

A special video connector found on many televisions and VCRs that produces a better-quality video signal.

Telephoto

A long focal-length lens that is used to magnify distant scenes.

Vignetting

An effect that darkens the edges of the picture. Sometimes this is intentional to emphasize the subject in the middle of the image, and sometimes it's accidental, caused by a lens adapter that blocks some of the light entering the lens.

Zoom

A zoom lens can change its focal length at the press of a button or turn of a dial. Zooms are handy for framing a scene or switching quickly from wide-angle to telephoto.

index

X

Z

THE AUTHOR: UP CLOSE

Dave Johnson writes about technology from his home in the Rocky Mountains. He covers digital photography in a weekly *PC World* email newsletter. He's an award-winning wildlife photographer and the author of fifteen books, including *Digital Photography Answers!* and *How to Do Everything with Your Digital Camera.*

Barbara J. Morgan Publisher, Silver Lining Books

I just bought a Digital Camera, Now What?! ™

Barb Chintz Editorial Director

Leonard Vigliarolo Design Director

Gail Zarr Editor

Ann Stewart Picture Research

Della R. Mancuso Production Manager

Marguerite Daniels Editorial Assistant